Nature Staged

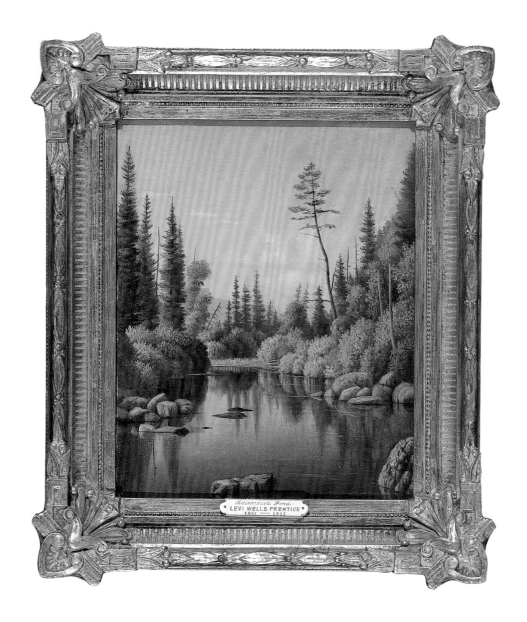

Adirondack Pond
LEVI WELLS PRENTICE
1851 ——— 1935

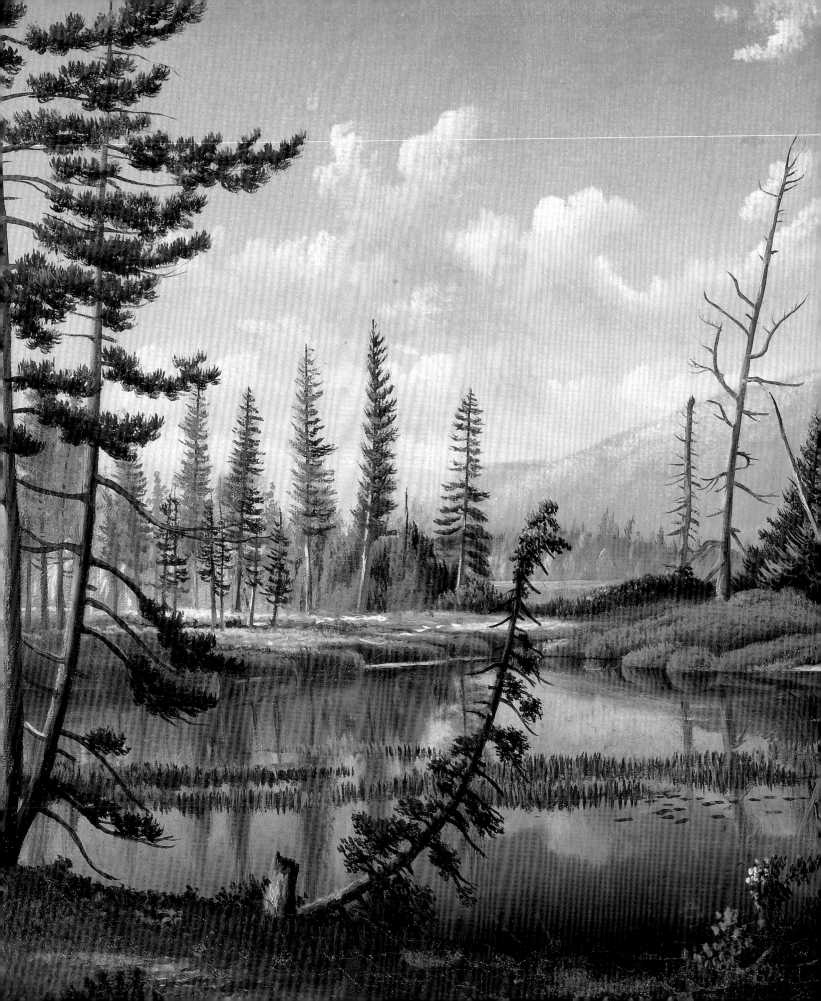

Nature Staged

THE LANDSCAPE AND STILL LIFE PAINTINGS

OF LEVI WELLS PRENTICE

Essay and Checklist by

Barbara L. Jones

THE ADIRONDACK MUSEUM

BLUE MOUNTAIN LAKE · NEW YORK

1993

L.W.Prentice

Exhibition: The Adirondack Museum
May 29–October 15, 1993

Exhibit and Project Director: Caroline Mastin Welsh
Catalogue Editor: Alice Wolf Gilborn
Checklist Editor: Tracy Nelson Meehan

Designed by Christopher Kuntze at The Stinehour Press
Typeset in Baskerville & Snell type on Warren's Lustro Dull text
Printed by The Stinehour Press, Lunenburg, Vermont

Research and Publication of *Nature Staged:*
The Landscape and Still Life Paintings of Levi Wells Prentice
was funded by the Adirondack Historical Association,
the New York State Council on the Arts, and private donations.
The exhibition was funded by the Adirondack Historical Association.

Cover: *Blue Mountain Lake, Adirondacks,* 1874
Frontispiece: *Landscape* "Mull Pond"
Title page spread: *Raquette Lake*

ISBN 0–910020–44–2

For her interest in the artist
and unfailing support to the museum
this volume is dedicated to
Joann Olson Fay

Contents

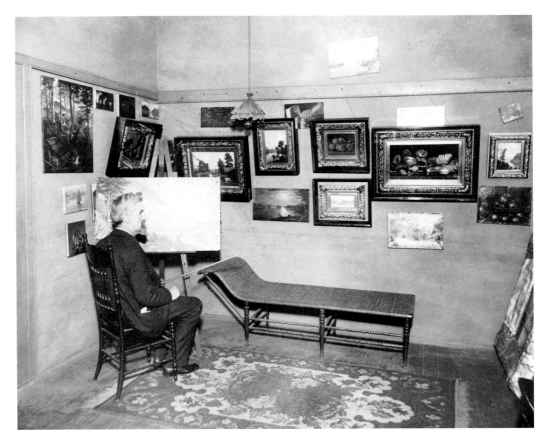

Levi Wells Prentice in his Brooklyn studio. Courtesy Adirondack Museum.

Preface

Nature Staged: The Landscape and Still Life Paintings of Levi Wells Prentice accompanies the first major exhibition devoted to this American artist. Perhaps even more important, the book and exhibition mark the first time that so many of this artist's works have appeared together and in a place which he pictured in a significant portion of his oeuvre. Born just outside the boundary of the Adirondack Park, Levi Wells Prentice painted this region's "watergems and sublime mountains" in over seventy known landscape paintings. For the Adirondack Museum, whose art collection is organized for the single purpose of documenting pictorially Adirondack places and people, the size of Prentice's Adirondack oeuvre sets him apart from the hundreds of artists who painted the North Woods between 1830 and 1930. Although Prentice's still life paintings have been more widely acclaimed than his landscapes in recent years, the contrary was true in his own time. That Levi Wells Prentice was singular "for his unusual talent in depicting the glorious lake and mountain beauty of the Adirondacks particularly," the museum can agree.

Art historians generally concur that images of wilderness are what is most "American" about American nineteenth century art. From 1830 to 1880, while many American artists found their muse in the frontier wilderness of their native land, others traveled to Europe to find their artistic roots in the great classical traditions of Western Art. By 1876, America, at 100 years old, was more secure in its self-image and less reliant on Europe for iconography; American artists were looking at themselves and the world in new ways and allying themselves with contemporary artistic styles. The innovative stylistic movement in 1880 on both sides of the Atlantic was Impressionism, an art based on color and light rather than factual depiction of the natural world. Levi Wells Prentice, however, was not swayed from his highly personal and individualistic style. Self-taught, he turned to nature and nature alone for his inspiration. Precise realism, concern with botanical detail and reliance on local color, much in the style of the English Pre-Raphaelites, was his consistent hallmark throughout

his artistic career. While his confreres traveled the continent, he did not leave his native shores, nor was he influenced by artistic innovations or changing styles.

Although Prentice began his career painting the Adirondack landscape, he depicted many other New York State locales, as well as scenes of Connecticut and New Jersey. In 1883, coincident with a move to Brooklyn, he changed his subject. While unresponsive to changing artistic modes of rendition, Prentice joined the popular trend among artists for painting still lifes. His brilliant, highly realistic arrangements of fruit and edibles comprise the largest volume of his oeuvre and were the first of his works to capture critical attention.

The Adirondack Museum's interest in Levi Wells Prentice began in the 1960s with former Curator William K. Verner's research on artists working in the Adirondacks. His notes, published articles, and purchases for the museum of several Prentice paintings formed the foundation for the museum's subsequent efforts. The year 1987 marked the beginning of a six-year commitment to produce an exhibition and catalogue raisonné of the artist's work. Former Director Craig Gilborn initiated the project with the appointment of Barbara L. Jones, an art historian educated at Syracuse University, as Research Associate and Guest Curator. Functioning as detective as well as art historian, by November of 1992 Barbara had located 271 paintings by Levi Wells Prentice, with many more identified but not yet found. She also reconstructed the sparse details of this peripatetic artist's life, from his birth in upstate New York in 1851 to his death in Philadelphia in 1935. Barbara's painstaking, thorough work and her insightful research was realized in the handsome exhibition and volume which inaugurated the Adirondack Museum's 1993 season.

Others at the museum have contributed to the project over the years. Museum Trustee Richard J. Fay and his late wife, Joann, expressed their personal interest in the artist by generously helping with the funding of the project. This book is dedicated to Joann Olson Fay. As Project Director, I was greatly assisted by Registrar Tracy N. Meehan and Curatorial Assistant Kathryn Benton, who handled a myriad of details necessary to the successful fruition of projects of this size and scope. Museum Editor Alice Gilborn edited the author's manuscript and managed the production of the catalogue in conjunction with Stinehour Press, which was a congenial and cooperative partner. Tracy Meehan served as editor of the checklist. Others have assisted with the formulation of programs and related events. The project also owes a debt of gratitude to the New York State Council on the Arts, which contributed toward the

funding of the work in its planning stages. New museum Director Jacqueline F. Day inherited the project in 1992 and presided over its conclusion.

Any major loan exhibition depends for its very existence on the generosity of lenders. We are grateful to the museums, galleries and private collectors who graciously parted with paintings crucial for the success of this exhibition. The collectors of Levi Wells Prentice paintings are an extraordinary group and, in large part, their devotion to him has made this project a labor of love.

Caroline M. Welsh
CURATOR

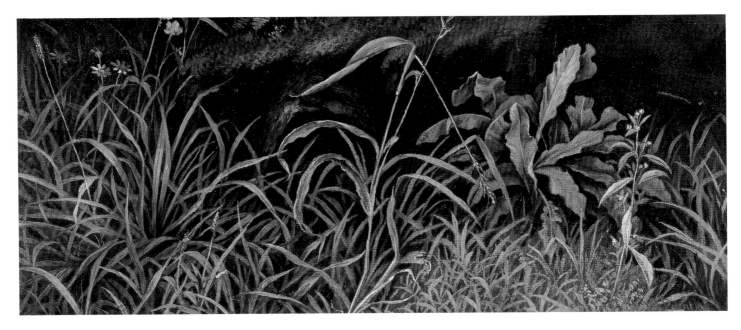

Forest Floor

Levi Wells Prentice, oil on canvas 5 x 11. Collection Remak Ramsey. Checklist no. 181.

Acknowledgements

THIS EXHIBITION and accompanying publication are the culmination of six years of research on the art of Levi Wells Prentice. In 1987, as a Research Associate for the Museum, I began to track Adirondack landscape paintings by Prentice. At that time, I was definitively aware of only the nine paintings in the Adirondack Museum collection, one at the Shelburne Museum in Vermont, and several in private collections; however, as of January 1, 1993, I had discovered nearly 300 landscapes, still lifes and portraits which now comprise the artist's checklist. I am certain that many more paintings exist, and I will continue my search for them, as well as my attempts to fill in the remaining blanks in the chronology of the artist's life. I am particularly indebted to the Adirondack Museum for allowing me the opportunity to curate this exhibition and author this catalogue. My thanks to Craig Gilborn, former Director of the Museum, for his foresight to bring the results of my work to fruition with this exhibition.

I am especially grateful to William H. Bender, Jr. and William K. Verner for their early interest in Prentice. Their in-depth biographical research on him formed the basis of my study. I am only sorry that they cannot be here to witness the results of their labor.

My special gratitude to the artist's family, Alberta Prentice Poppe, and Elizabeth Prentice Cassidy for their enthusiastic response to my numerous queries and their willingness to share their recollections of great-uncle Levi with me. I hope they will be pleased with the outcome.

Anne Van Gobes, neighbor and friend of Prentice's daughter, Imogene, has been an invaluable source of information on the artist, his family life and work. I thank her for her continued detective work on my behalf and her attempts to unearth the family secrets.

In my efforts to locate Prentice's paintings and to chronicle his long and productive life in Lewis County, Syracuse, Buffalo, Brooklyn, Philadelphia and Bridgeport, Connecticut, I have met and/or corresponded with a great many individuals, in both

the public and private sector, who have shared their time and information on the artist and his work with me. I would like to express my appreciation to the following people for their ongoing assistance through the many phases of this project. Each of them has contributed a valuable piece to this yet unfinished puzzle: Judy Haven, Onondaga Historical Association Research Library, Syracuse; Tom Hunter, Onondaga Historical Association; Janice Lurie, Albright-Knox Art Gallery Library, Buffalo; Marlene Hamann; Molly Keller; Chris Cox, Onondaga County Public Library, Inter-Library Loan Department; Clark S. Marlor, Brooklyn Historical Association; H.J. Swinney; Mrs. Dorothy Hawley; Elizabeth Goldberg and Joanne Klein, Christie, Manson & Woods, International; M.P. Naud and Susan Menconi, Hirschl & Adler Galleries; Frederick and James Hill, Bruce Weber, and Maria Reilly, Berry-Hill Galleries; Fred Bernaski, Kennedy Gallery; Leela Philip, Litchfield Auction House; Robert McLean, McLean Gallery, Albany; Naomi and Joseph Klein; Rodger Sweetland; Holly Goetz and Leslie Ann Gleidman, Sotheby, Parke Bernet, Inc.; Neva Conley, Town Historian, Sherburne, N.Y.; Roy Wood, Jr.; David Henry, Spanierman Gallery; Robert Schwartz; Dee Wigmore, D. Wigmore Fine Art; Gerold Wunderlich, Gerold Wunderlich & Company; Robert Vose, Vose Galleries, Boston; Richard York, Richard York Gallery; Tammis Groft, Albany Institute of History and Art; Michael Brown; John Bishop; Peter Fodera and Ken Needleman, Fodera Fine Arts Conservation Ltd.; Dennis DeLorenzo, Dennis DeLorenzo Fine Art; Donald Jones; Sylvia Reed; John Rexine, Everson Museum of Art, Syracuse; Thomas Norton; Marie Cole; Barbara McAdam, Hood Museum of Art, Dartmouth; Karen Jones; Joan Barnes; Henry Holt; Mr. and Mrs. Richard J. Fay; Barbara Evans, Lewis County Historical Society; Lauren Kintner, Mellon Bank; Paul Schweizer, Munson Williams Proctor Institute, Utica; Alison Hatcher; Eve Daniels and Carol Wood, Roberson Museum and Science Center, Binghamton; Walter and Lucille Rubin; Mr. and Mrs. Jerome Fischer; Pamela Scheffel, Rochester Public Library, Local History Division; Kenneth Rhodes, Sr.; Barbara Evans-Iliesieu; Carol Humphries; Marie Sorge; Reagan Upshaw, David Findlay, Jr., Inc.; Abigail Furey, William Doyle Galleries; Briget Brownell and Jennifer Greenfeld, The Albany Gallery; Mark LaSalle, Mark LaSalle Fine Art, Albany; George Turak and Lynn Candido, Lugakos-Turak Gallery, Philadelphia; Roland Augustine, Luhring, Augustine & Hodes Gallery; Walter Mayer, Buffalo and Erie County Historical Society; Phyllis Sharon Pransky; Raymond E. Adams, M.D.; William Tasman, M.D., Margaret DiSalvi, The Newark Museum, and those private collectors who wish to remain anonymous.

My special thanks to Dr. David Tatham at Syracuse University for his encouragement in this and all my endeavors. To Peter C. Welsh for his initial support in the early stages of this project and for his continued guidance as both a colleague and friend. To Linda Ferber for taking time from her busy schedule to read my manuscript and for her insightful editorial suggestions.

I appreciate the staff of the Adirondack Museum, especially Jerold Pepper, Librarian, Tracy Meehan, Registrar, Hallie Bond, Curator, Kathryn Benton and Jim Meehan, Curatorial Assistants, for their ongoing assistance over the years and Jacqueline Day, Director, for her current support. I am grateful to Alice Gilborn, Editor of Books and Publications, for her editorial skills, advice and continued patience throughout the many phases of this project. If it had not been for this project, I would never have met Caroline Welsh. I have been fortunate to work with her these past six years and thank her for her confidence in me, her expert curatorial advice and moral support, her commitment to this project, but most of all, for her friendship.

My family, John, Georgia, Zach, Jordan, Howard and Gail, I thank for their understanding when I couldn't be with them as often as I would have liked over the past six years. And my late parents, I thank them for their faith in me and unfailing support in everything I did. Their spirits continue to guide me. And to my friends, Mar, Tom, Susan, Dana, Kathy, Sherry, Jen, Evelyn, Eric, Dot, Kate, Leslie, Bruce and Meg, thank you for putting up with my endless ramblings on the subject of Levi Wells Prentice.

And last, but of course not least, I would like to express my gratitude to all of the public and private lenders to this exhibition. Without their ongoing support, cooperation over the years and their generosity in lending their treasures, this exhibition could not have been realized.

Barbara L. Jones
GUEST CURATOR

Lenders to the Exhibition

Anderson & Co. Fine Arts
Berry-Hill Galleries, Inc.
Mr. and Mrs. John Bishop
Lynn H. Boillot
Mr. and Mrs. Kenneth Bower
Gilbert Butler
The Carnegie Museum of Art
Mrs. James F. Chace
Herschel and Fern Cohen
The Detroit Institute of Arts
Mr. and Mrs. Robert G. Donnelley
Everson Museum of Art
Richard J. Fay
Charles F. Flanagan
Eleanor M. Foster
Mr. and Mrs. Howard J. Godel
Hood Museum of Art
Donald and Ann Jones
Walter and Anne Knestrick
Louisiana Arts and Science Center
Masco Corporation (Epic Fine Arts)

Edward and Vivian Merrin
Joan B. Mirviss and Robert J. Levine
The Montclair Art Museum
Museum of Fine Arts, Boston
Naomi's Art, Inc.
Onondaga Historical Association
Private Collections
Rahr-West Art Museum
Remak Ramsay
Mrs. John Davies Reed
The Regis Collection
Kenneth and Ruth Rhodes
Roberson Museum and Science Center
Albert Roberts
Walter and Lucille Rubin
William B. Ruger
Susan Ellis Stebbins
H. J. Swinney
Sylvain and Anne Van Gobes
John C. Wunderlich
Yale University Art Gallery

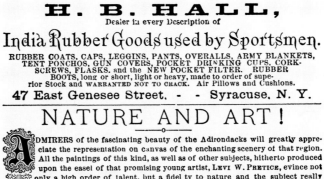

Nature Staged

BY THE TIME Levi Wells Prentice was first advertised and praised as a "promising young artist" in the 1875 edition of E. R. Wallace's *Guide to the Adirondacks* (facing page), he had already been painting the Adirondack landscape for nearly four years.[1] "Nature and Art" is an especially appropriate title for the ad, as Prentice clearly reflected the nineteenth century sensibility for connecting nature and art in his landscape paintings. "Mr. P.," as Wallace referred to the artist, would spend nearly twenty years of his career depicting the picturesque mountains, lakes and woodlands of the Adirondack region that he visited while living in Syracuse, New York. As a self-taught artist, his direct encounters with the North Woods landscape resulted in more than seventy highly personal and vibrant pictures of that pristine natural world.

In each painting, Prentice's distinctive vision, realized with a meticulous attention to detail, captured both the vitality and tranquility of the unspoiled wilderness. Created in the 1870s, his "faithful copies" of nature, and his paintings of the hotels around Blue Mountain Lake, recall an important decade in the history of the Adirondacks, when the territory was experiencing a surge of tourist and sporting activity.[2] Prentice recorded the actual details of the landscape before him and very often rearranged them to satisfy his own personal aesthetic, or that of a patron, just as a set designer uses component parts from real life to recreate a scene on stage. For Prentice, the natural world was delineated, detailed, caught in repose, but also possessed the potential drama of life and death.

In recent years, with the renewal of interest in nineteenth-century American realists, Levi Wells Prentice has gained deserved recognition as a still life painter, a subject he specialized in later in his career; as a landscape painter, however, and especially as an Adirondack artist, his contribution has been eclipsed for too long. Responding to popular interest in the wilderness of the Adirondack region, Prentice joined a distinguished group of artists who came to the North Woods and captured

scenes of them on canvas. Thomas Cole and Asher B. Durand visited Schroon Lake as early as 1837; William Trost Richards, Elizabethtown and Essex County; William James Stillman and John Frederick Kensett, Lake George; Winslow Homer, Minerva; Frederic Remington, Cranberry Lake —these were among the more than five hundred artists who traveled to the Adirondacks to paint between 1830 and 1930.[3]

SYRACUSE PREMIERE

Born December 18, 1851, the second son of Samuel Wells and Rhoda S. Robbins Prentice, Levi Wells Prentice grew up on a farm in rural Lewis County, very near the landscape he chose to paint. Harrisburgh, the artist's birthplace, is located just outside the "blue line" that would describe the boundaries of the Adirondack Park some forty-one years later.[4] By the time Levi Wells was nine years old, as the New York State census of 1860 indicates, he and his family were living in the town of Denmark, village of Copenhagen, Lewis County, where his younger brother, Franklin Kent, was born on January 27, and where, presumably, Prentice grew up in the 1860s. Although there is no record of the Prentice family from 1860–1869, real estate records reveal that on November 3, 1870, Samuel Prentice purchased a house in Syracuse. This new urban environment helped form young Levi's aesthetic sensibilities, and it was here, three years later at the age of twenty-one, that he made his public debut as a landscape painter. His first subject, one that had inspired numerous artists before him, was the Adirondack mountains. Throughout his career, Prentice also painted the Thousand Islands, Syracuse and central New York, Buffalo and western New York, the Pine Barrens in New Jersey, Bridgeport, Connecticut, and sites along the Hudson River, chronicling nearly every place he lived.

Prentice was essentially a self-taught painter, but his lack of formal education did not hinder him in his artistic pursuits, as he appears to have been financially self-sufficient all the years he lived in Syracuse. A reporter for the *Syracuse Journal* wrote on December 2, 1873: "Mr. Prentice has thus far been his own master. Whatever of development his rare genius has received has come through his own efforts." The artist's "own efforts" included copying the work of other artists, such as Arthur Fitzwilliam Tait (1819–1902), studying the Old Masters and contemporary paintings in exhibitions, or as lithographic and engraved reproductions published in numerous magazines and books of the period. Photography, especially the stereograph, also played an important role in Prentice's developing style. He may even have been

apprenticed to an engraver early in his career, which would account for his emphasis on drawing and his carefully articulated detail.

Prentice followed a self-prescribed educational path, begun by the Hudson River School and reinforced by John Ruskin's (1819–1900) truth to nature principals laid out in his book *Modern Painters*.[5] Although he can be allied to both schools of thought, Prentice cannot be considered a member of either. Indeed, he responded to the cultural milieu of his times by choosing a traditional approach to the landscape but, at the same time, he personalized his paintings by blending real details from his sketches made out-of-doors with a compositional design and exaggerated local color conceived and executed in his studio. By limiting his color palette and confining himself to a particular set of distinctive techniques that define his artistic style, Prentice remained outside the mainstream tradition of nineteenth century American art. His natural talent for painting the landscape and inanimate objects is apparent. His naiveté and lack of technical training are most evident in his attempts at architecture, animals, or human anatomy. In his six known animal "portraits," Prentice offers a more whimsical side of his artistic personality. Even while distorted and somewhat awkwardly handled, each one possesses a charming, near primitive quality that makes it appealing in its own right (plates 60,61,62,63 and checklist nos. 282, 283).

During the nine years, from 1870–1879, that Prentice lived in Syracuse, the city energetically supported his artistic activities. He drew high praise from enthusiastic Syracuse art critics who followed him closely, reporting his exhibitions, his painting trips to the Adirondack mountains and the duration of each of those visits. Most of the information available on Prentice's Adirondack period is provided by Syracuse newspaper reports from January 21, 1873, to March 19, 1895. Although he made only four trips to the mountains from Syracuse in the years spanning 1873–1877, the trips were highly productive and earned him a substantial reputation as an Adirondack artist. He returned to his studio each time with an array of oil sketches of Adirondack scenery that he subsequently transferred to canvas, sometimes years later. In the 1870s his route to the Adirondacks took him east from Syracuse to Utica via the New York Central Railroad. From Utica he continued north by stagecoach and entered the mountains through Old Forge, studying and sketching the landscape as he made his way further north along the chain of lakes to the central Adirondacks. The diverse imagery inspired by that majestic region became a compositional vocabulary upon which Prentice would draw for the next twenty years or more.

Prentice's first Syracuse studio was located at No. 14 Weiting Block and the

second, also the family home, at 16 Johnson Street.[6] He was first listed in the city directory of 1873 as "landscape artist," and later as "artist" in the 1875–1879 volumes. On November 1, 1877, the *Syracuse Journal* published an extensive report on the advantages of formal art training. Titled "Syracuse as an Art Center," the article was the third in a series on the merits of having a College of Fine Arts in the city and testifies to the active interest in art taken by the residents of Syracuse and to their attempts to attract artists and transform their city into an important art center during the time Prentice lived there. The article quotes Ruskin at great length, ratifying the continuing influence of the English artist's ideas on art in America during the second half of the nineteenth century, ideas to which Prentice was indirectly exposed. "The kind of art which we want here," it states, "is that which makes mankind better for its presence, that which appeals strongly to the religious feelings, inspiring in the people a desire to grow better and better every day. There is wealth enough in our city to render it an art center if sufficient interest can be awakened in behalf of art education."[7] Art organizations, such as the Syracuse Aesthetical Society, the Ladies Art Society, and the Social Art Club, where Prentice could view the work of the Old Masters and that of his contemporaries, were available to him by 1873.[8] James Cantwell (1857–1926), Fernando Carter (1856–1931), Henry Ward Ranger (1858–1916) and John Dodgson Barrow (1824–1906) were among the artists active in Syracuse with whom Prentice likely had contact. Although their painting styles were very different, they all shared a common interest in the natural landscape. This was especially true of Prentice and Cantwell, since they both painted the Adirondacks. The two may even have traveled there together in 1877.

ADIRONDACK SCENES

The first published account of Prentice traveling into the North Woods to paint appeared in the June 12, 1873, issue of the *Northern Christian Advocate* which reported that the artist "had gone into the Adirondacks to make sketches."[9] Just five days after that report, Prentice signed in at Lawrence's Hotel in Moose River, New York.[10] The earliest known Adirondack landscape by Prentice, however, is dated 1871, two years prior to the publicized trip. The date of that painting, *River Valley Landscape* (plate 1), is problematic because, six months earlier, on January 24, 1873, the *Syracuse Journal*—in its first critical review of the artist's first public exhibition—reported that Prentice's premier painting was not an Adirondack subject but a large oil painting "representing

a scene in the famous Valley of the Yo Semite [*sic*]" entitled *The Mariposa Trail* (checklist no. 121). The reviewer stated that *The Mariposa Trail* was the first of its kind for the artist who had been previously known only for a number of small works and several portraits.[11] This report, if reliable, contradicts the existence of the earlier Adirondack painting. If *River Valley Landscape* was actually painted two years prior to the artist's debut exhibition and review, as its date in the lower right corner clearly indicates, then it is surprising that the reviewer did not acknowledge it, since the painting is one of the artist's larger known works, measuring 3 by 5 feet, and should have been considered a major accomplishment for an artist who was barely twenty years old. The possibility does exist, however, that *River Valley Landscape* was the painting referred to as *The Mariposa Trail* in the newspaper reviews.[12]

The reviewer concluded by describing the *The Mariposa Trail* as "a masterpiece of a young Syracusan who for the first time asks public criticism of his work."[13] In the years preceding the Civil War many artists traveled west of the Mississippi in search of the grand landscape in unknown territories there. Despite his western subject, however, there is no evidence to suggest that Prentice ever heeded the call of "manifest destiny," or traveled any further west than Buffalo to paint. Instead, he chose to explore and document a frontier closer to home, that of the familiar wilderness to the northeast called the Adirondacks. Here, too, Prentice was following the spirit of the times by exploring and documenting unspoiled nature in paint on his native soil, and not that of Europe, as so many of his contemporaries did. His choice for his first large composition is curious but not at all surprising considering the popularity of the subject at the time. Prentice must have seen reproductions of the Yosemite Valley, created after paintings by Albert Bierstadt (1835–1902), Alfred Thomas Bricher (1837–1908), Thomas Hill (1829–1908) and others, that were published by lithographers such as Louis B. Prang & Company and made available to the public in chromolithographs as early as 1869. The specificity of the title of the painting *The Mariposa Trail* suggests that Prentice saw either the photographs taken by Carlton E. Watkins during his earliest trip to the Mariposa Grove just west of Yosemite in 1859 and the chromos based on that series of photographs which were also published by Prang or Charles L. Weed's photographs of the subject taken in the mid-1860s.[14]

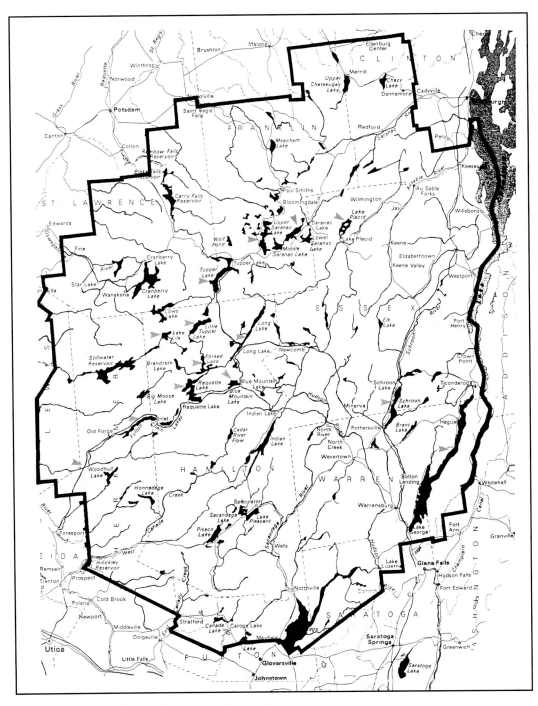

Prentice's route of travel in the Adirondacks during the 1870s.

Prentice made a second trip to the Adirondacks in 1873, this time for five weeks, as noted by the *Syracuse Journal* on November 1, 1873. Once again he registered at Lawrence's Hotel on October 29, 1873, on his way back to the city. A painting entitled *Moose River, Adirondacks* (plate 10) of 1884, documents his visit to that area, although it was rendered many years later, while the artist was living in Brooklyn, New York. The article noted that Prentice brought back a "portfolio richly stocked with sketches of the most picturesque points of that region of 'watergems and sublime mountains' arrayed in the most beautiful colors that the foliage of Autumn can give."[15] Specifically cited were Albany, Smith's, Big and Little Tupper, Saranac, Round, Long, Forked, Roquette [*sic*], Blue Mountain, and the Fulton Chain of Eight Lakes as the locales the artist sketched while in the mountains (see map, opposite) that season.[16] On November 26 of the same year the *Journal* announced that the artist would "exhibit about a dozen of his latest productions at his residence, No. 16 Johnson Street." Considering that at the beginning of 1873 Prentice was known only by a few small works, several portraits and *The Mariposa Trail*, just ten months later he had made two trips to the Adirondacks and completed "about a dozen" paintings—an early indication of the artist's prolific output. *Blue Mountain Lake, Round Lake, Head of Big Tupper Lake from Coleman's Point* and *Upper Saranac Lake* were the titles of four of these paintings discussed in a subsequent *Journal* article dated December 2, 1873. "Either of them," the reviewer stated, "is perfect in itself, but the group is most desirable. They present nature in nature's garb, and with a trueness that every tourist will at once recognize."[17]

Blue Mountain Lake, Adirondacks (plate 2) of 1874, vibrantly exemplifies Prentice's best work and includes almost his entire vocabulary of natural elements: the blasted tree and remnant of a tree trunk; one or more barren, dead trees; heavily striated and stylized rocks; and minutely detailed varieties of ferns, colorful plants and flowers native to the area. The only element missing, which appears in nearly every other Adirondack landscape Prentice painted, is the paper birch tree with its accentuated, unfurling bark. His obsession with the details comprising the landscape is apparent in sharply focused depictions of hard-edged, rigidly delineated trees, rocks and plants in the immediate foreground. Some of these act as *repoussoir* elements, effectively leading us into the scene—much in the same way the human figure did in seventeenth century Dutch paintings—while others, such as the fallen tree, restrict our entry. This conflict, or contradictory design, is similar to the dichotomy that Prentice sets up

between his usually dark foreground and light background. The foregrounds of his paintings are noticeably affected by finite changes, by the ever-present conflict of death and rebirth, whereas the backgrounds, the lightest portion of the paintings, are bathed in an all-pervasive light, intimating a natural connection to the infinite or Divine Spirit. This duality, from the objective to the subjective, from realism to romanticism, incorporates the two dominant artistic styles in 1870s America.[18]

The middle ground of *Blue Mountain Lake, Adirondacks* is comprised of a promontory on both the right and left side and an island, just right of center, surrounded by the lake. The extreme horizontality of this scene allows us to "read" the painting in layers or stages, all of which, ultimately, are interrelated through the reflections of the respective elements in the placid water. The barren tree and littered foreground catch our eye at once. We are led by the tree and broken branches lying on the ground horizontally across the front of the picture plane, off the edge of the canvas, and back onto it by the projection of the promontory into the lake from the right, then on around the lake to the crescendo of mountains located at left. With the curve of the middle ground which again meets the foreground integrated through the reflections of trees in the water, we complete the circle. Quiet pervades the scene, capturing a moment in time, of co-existence with nature on a beautiful autumn day in an unpopulated wilderness. No human or animal presence is apparent; no boats are on the lake; there is no activity save clouds suspended in the hazy, sunlit sky. The scene is filled with the silent energy of the cycle of decay and growth. Autumn was obviously Prentice's favorite time of year, as he repeatedly represented this colorful season of glorious golds, oranges, and reds. Prentice was known to have painted at least one winter scene, but that painting has not been located.

The background of the painting is atmospheric, composed of several layers of mountains that become less defined as they recede into space. Each curvilinear mountain form is delineated from another, although their shapes are rendered lighter and lighter as they begin to fuse with the sunlit sky, implying that the vista is endless. The way the sky meets the contour of the mountain range suggests an intimate relationship between earth and heaven, solid and void, connoting the artist's aware-ness of the Transcendental idea of being and becoming espoused by Ralph Waldo Emerson and others of the early nineteenth century. Prentice's manipulation of per-spective in this landscape is intended to suit the design of the composition. His extreme foreshortening of the lake in nearly all his landscape paintings renders the

mountain range more prominent, thus making the scene visually more powerful. Here again we a find synthesis of fact and artistic technique to elicit a strong response to the picture.

In the artist's first review (January 24, 1873), the writer mildly criticized the composition of *The Mariposa Trail*, although he did not attribute the picture's faults to Prentice himself. "The artist," he stated, "is not responsible for nature's freak in organizing the scene somewhat contrary to an artist's ideal of perfection, by laying before the eye a foreground, middle distance and distant mountains, all almost without connecting relations, and yet this peculiarity gives it attractiveness."[19] That observation is particularly apt, since the "peculiarity" described in the review is precisely the design that Prentice adopted for his first and for the majority of his subsequent landscape compositions. Prentice created nearly all his landscapes as if they were a theatrical stage, replete with a meticulously detailed set of natural props; a few even include a performance. In almost every instance, his landscapes unfold before the viewer as a series of planes, parallel to the pictorial surface.

Prentice's very method of composition as described above suggests how strong an impact photography, especially the stereograph, had on his work. The stereograph was an extremely popular and commercial success during the late 1860s and 1870s in America. It was sold through catalogs, newspaper advertisements, by subscription, mail order and door-to-door by traveling salesmen.[20] At least four stereograph companies were operating in Syracuse in the 1870s.[21] The many stereoscopic photography subjects available—natural views of Yosemite Valley, the White Mountains, Niagara Falls, the Catskills and the Thousand Islands—were published in such widely-read magazines as *Scribner's* and *Munsey's* for a public eager to buy. The devices stereoscopic photographers used to achieve a greater illusion of three dimensions were precisely those Prentice used in his landscape compositions: the horizontal ordering with framing devices such as trees on either side; a dark, sharply focused foreground and light atmospheric background; cropping on all sides; and the sense of capturing a moment in time. According to Elizabeth Lindquist-Cock in *The Influence of Photography on American Landscape Painting, 1839–1880*, "The use of rocks, fallen logs, and other debris in the immediate foreground is typical of the stereoscopic photograph, which used every means to make the spectator so conscious of three-dimensional depth that he have the illusion of being inside the scene, not merely looking at it."[22] By littering the immediate foreground of his paintings with carefully rendered objects, Prentice

draws us into his scenes, taking us from an intimate view of a forest interior out onto the vast expanse of a lake, and still further, to the mountains beyond. Asher B. Durand (1796–1886), Thomas Cole (1801–1848), Frederic Church (1826–1902), and Albert Bierstadt, among others, were also known to use the photographic medium as an aid in recalling or as a means of preserving a particular scene that they wanted to paint later in their studios.[23]

Dated 1874, the view of Blue Mountain Lake was in all probability completed by Prentice in his studio after his trip to the Adirondacks the year before, in late September or October.[24] This method of working was verified by his daughter Imogene. Prentice would make oil sketches, she said, in sketchbooks and on single sheets of paper during his travels. Unfortunately, these sketches disappeared with the contents of Imogene's home in Philadelphia at the time of her death in 1974.[25] We know Prentice painted at least nine views of Blue Mountain Lake—in both known and unknown locations—(plates 2,3,6) and (checklist nos. 1,18,59,60,61,62), as well as others that might represent the lake but remain untitled.

Big Tupper Lake, Mt. Morris in the Distance (plate 4) may depict that lake from Coleman's Point, probably a private camp, and could be the work previously mentioned in the December 2, 1873, *Journal* report. Prentice painted two known canvases of Saranac Lake (checklist nos. 33,44), the third title mentioned in the same newspaper report, and while neither one is specifically titled Upper Saranac Lake, one of them could very well be that view. No painting of Round Lake, the fourth title mentioned, has yet been located.[26] The December 2 article also mentioned a fifth painting of "a scene taken from the foot of No. Four of the Chain of Lakes." That painting (location unknown, checklist no. 70) was "the best of all and challenges the most critical admiration." The reporter went on to say that "He who worships nature as his God, might well adopt this painting as his idol."[27]

The ideas of God existing in Nature and God as Nature were essentially synonymous during the early decades of the nineteenth century, creating a national morality expressed by artists throughout the century. American artists growing up during this period could not escape this prevailing sentiment. In 1835 Thomas Cole wrote:

> It is a subject that to every American ought to be of surpassing interest; for, whether he beholds the Hudson mingling waters with the Atlantic—explores the central wilds of this vast continent, or stands on the margin of the distant Oregon, he is still in the midst of American scenery—it is his own land; its

beauty, its magnificence, its sublimity—all are his; and how undeserving of such a birthright, if he can turn towards it an unobserving eye, an unaffected heart![28]

Cole's ideas expressed in his famous *Essay on American Scenery* guided Prentice in his art. Indeed, the artist did not turn towards the American scenery "an unobserving eye," or "unaffected heart!" Although the majority of his landscapes were not sublimely awesome renditions, nor concerned with the same moral and didactic considerations of Cole, Prentice assimilated the importance and the power of the landscape through the work of that noted leader of the Hudson River School of painters. Prentice was not emulating Cole's "higher style of landscape" but was attempting a factual recording of the American wilderness, combined with his own imaginative manipulation of light and color, texture and line, that brings to life for the viewer the essence of his Adirondack experience, preserving for all time the region as he witnessed it.

Blue Mountain Lake, Adirondacks epitomizes the notion of the "new" sublime in late nineteenth century American landscape painting. The scene Prentice painted is not awe-inspiring, nor is it mysterious or frightening, as Thomas Cole, Salvator Rosa and others interpreted the term sublime in their paintings earlier in the century. Rather than a grand tumult of noise, Prentice presents a sublimity of silence and tranquility, seen also in the Luminist paintings of Martin Johnson Heade (1819–1904), John Frederick Kensett (1816–1872) and Fitz Hugh Lane (1804–1865) where light and quiet reign.

Prentice's handling of minute details painted with tiny brushes allies his work even more closely with that of Asher B. Durand and the philosophy of John Ruskin than with Cole. The reviewer of Prentice's early painting, *The Mariposa Trail*, praised him for his close study of nature—"every color and flower"—and his faithfulness to detail in depiction of the mountains, the river, and the rich vegetation. "This 'land of flowers'," the reviewer maintained, "has been the study of many artists, and one acquainted with its beauties declares that the tinting of this painting, showing most gorgeous hues upon flowers and foliage, is exceedingly true to nature." Ruskin instructed artists, through his writing and his art, to go to nature directly for everything they needed in their art: "Every class of rock, earth, and cloud, must be known by the painter, with geologic and meteorologic accuracy." [29] If you could see an object, he thought you should paint it. Ruskin believed that a finished work of art was an accumulation of the facts and, as a result, the truth. He continued:

FIG. I *Asher B. Durand,* Kindred Spirits, *1849. Oil on canvas 46 x 36.*
Collection New York Public Library, Astor, Lenox and Tilden Foundations.

The landscape painter must always have two great and distinct ends; the first, to induce in the spectator's mind the faithful conception of any natural object whatsoever; the second, to guide the spectator's mind to those objects most worthy of its contemplation, and to inform him of the thoughts and feelings with which these were regarded by the artist himself.[30]

In 1855, Durand wrote:

I refer you to Nature early, that you may receive your first impressions of beauty and sublimity, unmingled with the superstitions of Art—for Art has

its superstitions as well as religion. . . . Take pencil and paper, not the palette and brushes, and draw with scrupulous fidelity the outline or contour of such objects as you shall select. . . .[31]

Prentice pays homage to Durand's *Kindred Spirits* (fig. 1) in his *Adirondack Scene* (plate 5), a vividly painted depiction of a miniscule figure standing alone on the edge of a large boulder, overlooking the monumental landscape. The only other human presence is one or two figures in a rowboat visible on the lake. Prentice's fidelity to natural details reflects his keen interest in the natural sciences and the botanical and geological accuracy mandated by Ruskin and the Pre-Raphaelites.[32] Although Prentice had no direct contact with these artists, he assimilated their philosophy by seeing their work, through publications and the work of his contemporaries who followed their doctrines, such as William Trost Richards (1833–1905), an eminent American Pre-Raphaelite who exhibited in Syracuse in 1877 when Prentice lived there, and also in the 1878 Utica Art Exhibition that Prentice attended.[33]

HOTELS ON THE LAKE
AND CAMPING BY THE SHORE

In 1877, four years after his first trip, Prentice returned to Blue Mountain Lake on at least two separate occasions.[34] During these visits he documented the area's hotels as well as its landscape. Escaping everyday life in the city, either staying in grander style in hotels overlooking the lakes or by roughing it in tents or cabins in the woods, the public, as vacationing tourist, sought the sanctuary of the Adirondacks. On August 28, Prentice's name appears in the hotel register of Miles Talcott Merwin's Blue Mountain House.[35] A painting presumably created after that visit, entitled *Blue Mountain Lake, Adirondacks from Merwin's*, (checklist no. 62) is known to exist but has not been located. It is recorded, however, in a sepia photograph taken by G. F. Gates of Syracuse (fig. 2).[36] Although no visible signature appears in the photograph, the image contains many of the artist's characterizing elements and is created with the same precise and realistic style that Prentice employed in his landscapes. According to William K. Verner, former curator at the Adirondack Museum who conducted preliminary research on Prentice, the painting "is particularly notable for the two boats on the lake [on the left and right of center] and the two rising plumes of smoke, one from the vicinity of the present steamboat landing, the other from the vicinity of Eagle

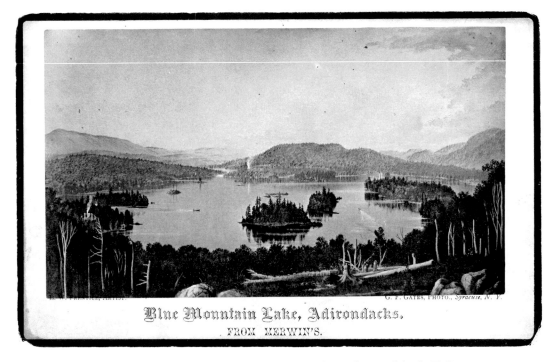

FIG. 2 Blue Mountain Lake, Adirondacks from Merwins. *Sepia photograph by G. F. Gates. Courtesy Adirondack Museum.*

Nest on Eagle Lake. This painting may be about the earliest representation of the island and view from Merwin's or from the present Adirondack Museum site. . . ."[37] Because of the increase in suitable, and in some cases luxurious, lodging, and an easier stagecoach route from North Creek, the hamlet of Blue Mountain Lake became a popular resort area in the second half of the nineteenth century.[38]

A second sepia photograph by Gates entitled *Blue Mountain House, Adirondacks* (fig. 3) shows Prentice's painting of the first hotel on Blue Mountain Lake, the Blue Mountain Lake Hotel, built by its proprietor John Holland and opened in 1875.[39] The view Prentice depicts is from a site across the lake from Holland's hotel and southwest of Merwin's Blue Mountain House. Blue Mountain, with its prominent rock slide and characteristic peak, looms over Holland's hotel at the left. The slope of its contour directs our eye toward the dwarfed Blue Mountain Lake Hotel, situated almost at the exact center of the background. Two tiny rowboats create the only disturbance in the otherwise perfectly calm lake constituting the middle ground. The unusually empty foreground of the picture leads us off the canvas at left, onto the island where the plume of smoke, indicating the presence of additional unseen campers, leads to Blue Mountain.

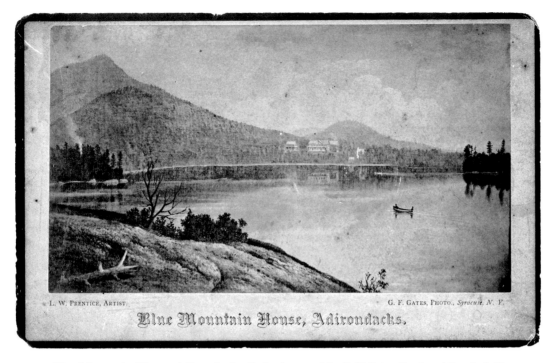

L. W. PRENTICE, ARTIST. G. F. GATES, PHOTO., *Syracuse, N. Y.*

Blue Mountain House, Adirondacks.

FIG. 3 Blue Mountain House, Adirondacks. *Sepia photograph by G. F. Gates. Courtesy Adirondack Museum.*

Continuing in his reportorial manner, Prentice also documented the third hostelry to be built on Blue Mountain Lake. *Blue Mountain Lake with Ordway House* (plate 3) is not dated but had to have been painted between 1877, the year the hotel opened, and spring of 1881, before its porch was razed, significantly altering its appearance. The Ordway House (also known as the American Hotel) was erected on Prospect Point, a promontory that extends into Blue Mountain Lake from the south.[40] Prentice depicted his view of the Ordway House from a vantage point high above the lake, perhaps from a site just south of Merwin's. The stage is set by a foreground framed with pines and a minimal amount of ground on which the artist stood to obtain his view. The lake again comprises the middle ground where Prentice recorded three boats, the three-storied hotel on Prospect Point at the left, and an unidentified building on Thacher's Island opposite the Point, all overpowered by their surroundings.[41] In the middle of the lake, a deer, its head just above water, swims away from one of the rowboats—the artist's only depiction of this frequently-used nineteenth-century hunting technique. The small figures, seated on the front porch of the hotel, relax and enjoy the natural landscape that surrounds them. Within the multiple layers of background mountains, Eagle Lake, located behind and to the southwest of the hotel,

is just barely visible. By minimizing the presence of the hotel, boats and camp, Prentice subordinated all these references to human intervention in the wilderness in favor of the monumental autumnal landscape.

Blue Mountain Lake and the three original hotels situated around it are also recorded in a lithograph by G. M. Lees & Co. of Syracuse (fig. 4). Created after one of the artist's paintings of the subject (location unknown, checklist no. 61), the hand-colored lithograph is not dated, but since it contains all three previously mentioned hotels on the lake in their original form, the artist must have painted or at least sketched the scene during the same three-year period as *Blue Mountain Lake with Ordway House*. The image is reversed because of the reproduction process, so each hotel is depicted opposite its actual location. Due to the sketchy nature of the lines in the print, it is conceivable that the lithograph was made from one of Prentice's sketches rather than from a finished oil painting.

Camping scenes were another popular theme in Prentice's Adirondack paintings, and seven known images of that subject exist (plates 6,7,8,9,10 and checklist nos.

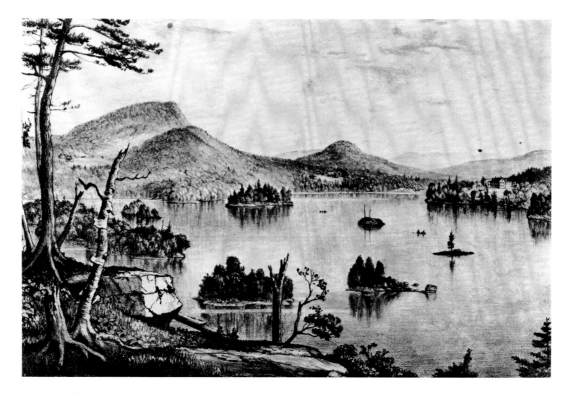

FIG. 4 *Blue Mountain Lake and Hotels. Lithograph by G. M. Lees & Co. Courtesy Adirondack Museum.*

1,75). As in Prentice's day, campsites dot the lakes and woods of the Adirondacks in two forms. Temporary camps consist of one or more bark lean-tos, constructed by hunters or guides leading hunting parties, such as those popularized by Arthur Fitzwilliam Tait, Frederic Remington and others in their paintings, or permanent camps, which are more established and comfortable sites, built and owned by individuals who schedule frequent sporting trips to the Adirondacks.[42]

Camping by the Shore (plate 6) and *Adirondack Camp near Blue Mountain Lake* (fig. 5) are examples of a small number of Prentice's paintings that are essentially replicas. In almost every other case—when the artist created a similar composition—he rearranged the elements significantly enough to create the impression of a new and unique scene; however, these two nearly identical camping scenes contain only a slight reordering of the iconographical elements. The dimensions of the paintings are the same, and within them, the two men, the rowboat, the platform tent, the bark and log cabin, the dining hut, the pine trees, the broken stumps, the lake, and even the still life arrangement on the table are the same. Only slight differences can be discerned. In *Camping by the Shore*, Prentice added one small pine tree next to the lake,

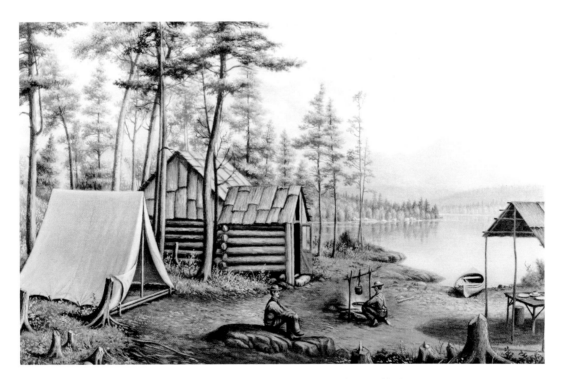

FIG. 5 *L. W. Prentice,* Adirondack Camp near Blue Mountain Lake. *Checklist no. 1. Private Collection.*

37

several more tree stumps near the cabin, and an extra log in the cabin, while he eliminated the stone step to the cabin seen in *Adirondack Camp near Blue Mountain Lake*. Neither painting is dated. The first of the two paintings could have been based on a semi-permanent camp located on Blue Mountain Lake where the artist stayed. The second version was probably created later, when the artist was no longer traveling back and forth to the Adirondacks, either from sketches of the area or from the original oil painting, at the request of a patron who wanted an Adirondack record of a previously visited locale. Which of the two versions came first is difficult to determine. The single pleasure rowboat pulled up on shore was usually found in more permanent camps, since it was not as portable as the Adirondack guideboat. Neither elaborate hunting gear nor guns are visible in the scene, and the meal being prepared by the guide at the campfire does not appear to be fish or game. This is the type of camp Prentice would have preferred for himself, since he was there to paint and not for sport.

The two men depicted in both camp scenes, a guide and his client, are generic figures that Prentice used whenever one of his genre scenes required an Adirondack guide or camper. Although most of his scenes were devoid of human references, Prentice sometimes included an architectural element, such as a hotel or a cabin, to suggest human presence. In these paintings, it is difficult to ascertain which figure represents the guide and which one is the member of the camping party, since both are dressed alike. While he continued to incorporate the same figures in his other paintings of this subject, Prentice distinguished one from the other by their clothing. The seated man in the foreground, his hands resting on bent knees with his feet crossed at the ankles, strikes a contemplative pose, absorbed in his own thoughts, meditating on the surrounding landscape. The second man, preparing the meal, squats stiffly before the campfire. No other campers are in sight, but the way Prentice crops the bark-covered dining table at right, revealing only two partial place settings, may suggest the imminent arrival of other members of the camping party, still out on the lake or in the woods. The camp seems too large for just two people.

Both pictures are thinly painted, a characteristic of Prentice's work that allows the grainy canvas to "read" as part of the textural surface. The cream color of the primed linen canvas contributes to the painting's underlying warm tonality; however, the intensity of color applied to it by the artist often negates that warmth. The lack of excessive impasto pigment and little or no varnish give Prentice's paintings their "dry" appearance. A pencil outline of Blue Mountain in the background delineates it from the other mountains and from the promontory extending into the lake. The

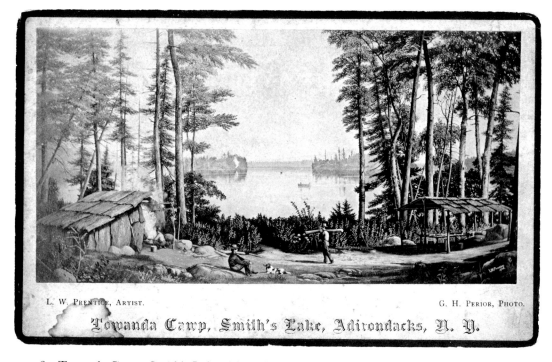

Towanda Camp, Smith's Lake, Adirondacks, N. Y.

FIG. 6 Towanda Camp, Smith's Lake, Adirondacks, N.Y., *1878. Sepia photograph by G. H. Perior. Courtesy Adirondack Museum.*

midday light over the camp scene is evenly diffused, though dark shadows are evident in the immediate foreground. The image fades as it moves further back into space where subtle variations in color distinguish mountain and sky. Opposing diagonals divide the scene almost equally into four triangles.

Prentice's other five known camping scenes all contain one or more of the same elements seen in these two pictures. Each retains its own distinctive qualities and characteristics, though similarities between scenes were not unusual, as the lean-tos, bark and log cabins and cook sheds the artist depicted were vernacular architectural types in the North Woods. The *Syracuse Journal* had announced that Prentice accepted commissions on any subject requested and painted any locale preferred.[43] An example of the artist painting "any locale preferred" can be seen by comparing *Towanda Camp, Smith's Lake, Adirondacks, N.Y.* (fig. 6), with *Moonlight Camping at Schroon Lake* (plate 7) where middle ground and background repeat in both pictures. The former painting, dated 1878 and known only through a sepia photograph taken by G. H. Perior of Syracuse, records a campsite that is located on Smith's Lake, known today as Lake Lila.[44] A prominent characteristic of the lake, its two promontories that project out into the water forming an inlet, can be seen in the background of both of the above-mentioned paintings. In addition, the smoking campfire on the left, and the trees on

both sides of the background, are the same in each picture. Two boats, albeit in slightly different locations, are visible on the lake, just right of center in the former, and in the center of the latter painting. The left foreground in each picture is replicated, with the exception of a few trees eliminated from the earlier version. The latter painting, dated 1890, was painted after Prentice had been living in Brooklyn, New York, for seven years. Since we have no record of Prentice traveling to the Adirondacks after 1880, we can surmise that he borrowed the background and foreground elements for this painting from a work that he had created earlier to satisfy a patron's request; or perhaps, working from multiple sketches, he interchanged excerpts from the landscape to suit the design he was initiating. Corroborating evidence that the locale Prentice depicted was indeed on Smith's Lake was offered by the *Syracuse Courier*, April 23, 1878:

> There is on exhibition in the window of Kent and Miller's clothing store a painting by our townsman L.W. Prentice, which is a most meritorious production. It represents Towanda Camp Smith's Lake, in the Adirondacks. The camp was built by a party of gentlemen form [*sic*] Towanda Pa and is pitched in one of the most attractive and beautiful points on the Lake. The artist has been most happy in reproducing upon the canvass [*sic*] the natural beauties of the surroundings of the camp. In the foreground are the cabins, and the guides preparing the evening meal while in perspective the beautiful lake stretches out for a long distance flanked on either side by dense foliage.[45]

Prentice's signature cast of characters appear in both paintings. In *Moonlight Camping at Schroon Lake*, the Adirondack guideboat on shore and the gun propped against the lean-to at left indicate that Prentice was traveling with a hunting party, and was not on a pleasure trip as in the painting of Towanda Camp. On a beautiful, tranquil evening a single guide prepares the evening meal and waits for the other campers to return for the night. The scene, illuminated only by the full moon and the light of the campfire, is not as sharply focused as Prentice's daylight views. Here, the artist utilizes a gestural, suggestive technique, more in keeping with the color harmonies in the tonalist style of George Inness' landscapes, to emphasize the subtle, more romantic aspects of a particular time of day.[46] Clouds covering the moon diminish its light and enhance the play of light and dark shadows upon the rocks and other foreground elements. At night, darkness blurs our vision, shadows soften hard lines, and objects, vividly apparent in daylight, begin to dematerialize before our eyes.

On the other hand, *Towanda Camp, Smith's Lake, Adirondacks, N.Y.*, a daylight scene, is portrayed as a more animated camp. Two of the three figures are active: one kneels beside the campfire and cooks the meal while another carries firewood toward the cook shed. The third man is seated in the now familiar contemplative pose. Notable similarities between this picture and another, *Watertown Camp, Albany Lake, Adirondacks, N.Y.* (plate 8), include the black and white dog lying in the center of both compositions, the stock figure with bent knees (once again seated on a rock as in *Camping by the Shore*), and the cook squatting at the campfire. The dining table is set for four, in anticipation of, presumably, the man in the boat on the lake in the middle distance.[47]

In *After the Hunt* (plate 9) of 1879, Prentice shows five men gathered around a campfire, seated in or near a temporary lean-to. Their hunting finished for the day, their evening meal completed, the men sit silently, each absorbed in his own thoughts. Evidence of the day's hunt—a deer hide hanging on the lean-to, a fish net hanging inside, a rifle, and the hunting dog—suggests that the artist was again accompanying a hunting party into the woods. The dining shelter and Adirondack guideboat are the only two elements in this painting similar to the other camping subjects previously mentioned. As in *Moonlight Camping*, the artist depicted this campsite at night, the scene illuminated by the moon and roaring campfire which highlights the face of each camper, his individuality retained. *After the Hunt* can be compared to A. F. Tait's painting *A Good Time Coming* (fig. 7) of 1862, published as a lithograph by Currier & Ives in 1863 as *Camping in the Woods, A Good Time Coming*. Perhaps Prentice's painting was commissioned by someone who had seen Tait's painting and wanted something similar. On the other hand, Prentice was well aware of Tait's work and may have been inspired to create his own version after seeing Tait's painting or chromo on the subject.[48]

Tait painted his campsite from Constable Point (now called Antler's Point) on Raquette Lake with four men, two dogs, hunting paraphernalia, one boat, and a lean-to. The finely detailed campsite and figures dominate the scene in Tait's depiction, whereas Prentice placed more emphasis on the landscape rather than on the campers themselves—set off to the right—who become less important than their surroundings. Prentice's portrayal is consistent with his subordination of human elements to the natural environment in all of his landscape paintings. Prentice focused on the passive and quiet, rather than on the more active or animated, aspects of the wilderness that Tait, Stillman, Homer and other Adirondack painters portrayed.

In *Moose River, Adirondacks* (plate 10) of 1884, Prentice depicts a portion of the

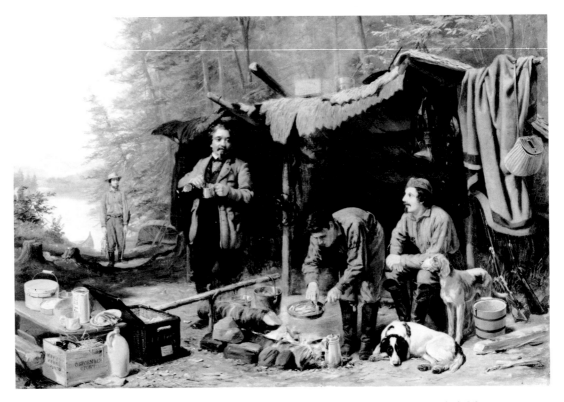

FIG. 7 *A. F. Tait,* A Good Time Coming, *1862. Oil on canvas 20 x 30. Collection Adirondack Museum.*

river and surrounding woods in great detail. He effectively draws us into the scene by including an early Adirondack guideboat, moored horizontally in the sharply defined foreground, that points to a path in the woods at right. Barely visible in those woods, further up the path along the river, is a lean-to where two men are shown squatting around a smoking campfire.

RAQUETTE LAKE

Raquette Lake, named for the French word meaning snowshoe, was one of Prentice's favorite and most frequently painted Adirondack subjects.[49] Twelve known paintings with that title exist, ten of which have been located (plates 11,12,13,14,15,16; checklist nos. 13,15,35,39; and locations unknown, checklist nos. 72,73). Three of these paintings, *Raquette Lake from Wood's Clearing* (plate 13) of 1877, *Raquette Lake* (plate 14) and *Raquette Lake* (fig. 8) of 1883, portray a specific site on the lake called Wood's Clearing, named after Josiah Wood, the original settler on Raquette Lake in 1846.[50] The

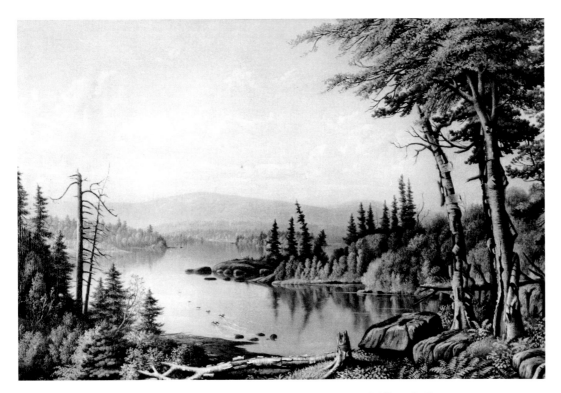

FIG. 8 *L. W. Prentice*, Raquette Lake, *1883. Checklist no. 35. Collection William B. Ruger.*

middle ground and background of each are nearly interchangeable; only the immediate foregrounds, filled with a profusion of minutely-painted picturesque elements, differ in any significant way. All three incorporate the same formation of ducks. A painting by Prentice on exhibition in the windows of the clothiers Kent and Miller's store, "Racquette [*sic*] Lake from Wood's Place, in the North Woods," was noted by the *Syracuse Courier* of March 25, 1878, to be "exceedingly natural and the coloring . . . life-like and excellent" and "undoubtedly the best yet produced by this rising young artist."[51]

These three versions of Raquette Lake from Wood's Clearing were adapted from the same oil sketch of Wood's Place that Prentice painted during his 1877 stay in the North Woods (plate 13 is dated 1877; plate 14 is undated and fig. 10, of 1883, was completed six years later). The stillness enveloping the scene is broken in two of the three pictures only by the movement of the ducks taking flight off the lake. In each picture, the artist leads us into the scene in a zigzagging motion from the immediate foreground through the middle ground to the background. Prentice's characteristic

vocabulary of compositional elements—the sensuously unfurling bark from the birch trees, the blasted and broken tree stumps, the dead pair of trees, the swaying pines, the lichen-covered and carefully striated and stylized rock formations and the identifiable ferns and flora—appear in every version of Raquette Lake. Elements of nature which Prentice had sketched in oil on the spot while he was traveling in the wilderness became part of his stock portfolio. Just as particular props in the theater can suggest a certain play, these scenic elements were emblems for the Adirondacks to Prentice. He consistently pictured living, dying and dead nature in all of his landscapes, with a vitality expressive of the dynamics of nature's cyclical process. As one tree dies, another breaks through the ground to take its place. Prentice's painstakingly detailed portrayal of the unfurling birch bark in *White Birches of the Racquette* [*sic*] (plate 16) exemplifies that vitality.

Prentice altered his viewpoint for all twelve Raquette Lake scenes. He depicted each one from a slightly different angle and cropped on all sides, similar in design to a landscape photograph which only captures the portion of the scene accessible in the viewfinder of the camera. Their serial quality, and that the majority of them are site-specific and often recognizable, suggests the commercial appeal of a photograph or postcard. It is not known whether Prentice took any photographs of his own or whether he even owned a camera, but, as mentioned earlier, working from photographs was fairly common practice among artists at that time. Prentice's three known seascapes (plate 22, checklist nos. 104, 132), with their high sky, extreme horizontality and minimal shoreline reveal that the artist was certainly aware of the compositional devices, used by the Luminists, to suggest limitless and boundless scenes. He presents only one view to us while intimating that an infinite number exist for the making. These paintings, with white caps frozen in time, recall not only those of Martin Johnson Heade but also Willliam Trost Richards' seascapes of the 1870s. Prentice's *Seascapes*, presumably painted off Long Island where his mother and brother Franklin lived in the 1880s, differ from his other landscapes in that they are not laid out so rigidly into three distinct planes. Instead, he synthesizes foreground, middle ground and background to create the whole.

Prentice also painted three known versions of Smith's Lake (Lake Lila). *Smith's Lake, Adirondacks, N.Y.* of 1883, in the collection of the Adirondack Museum (plate 18), and the Shelburne Museum's Smith's Lake, *Lake Lila in the Adirondacks* (fig. 9), both depict a view looking southwest from Mt. Frederica and, except for their size and altered foreground, are virtually identical. The latter version, while jewel-like and less than half the size of the former, is just as monumental in scale. Prentice has taken liberal artistic license in his re-interpretation of the scene, recording many more layers of mountains than can actually be seen with the naked eye. Through foreshortening and his manipulation of perspective, he emphasizes the power of nature by bringing the mountains closer to his viewers.[52]

The two views Prentice created from Mt. Frederica are the most dramatic of any of the artist's landscapes. Elevated high above the lake, we find ourselves on the edge of the summit with very little ground to stand on, where an undefined and obstructed path leads to the ominous ledge on the left side of the painting. Prentice suggests, in the Shelburne Museum view especially, that there is no substantial place to stand, except on the rocky ledge at left, a potentially dangerous place to be. In the Adirondack Museum version of the scene, Prentice positions himself further to the west, altering the foreground so that we feel even less firmly planted and seemingly in greater danger, because more trees, rocks, boulders, plants, and broken branches clutter the

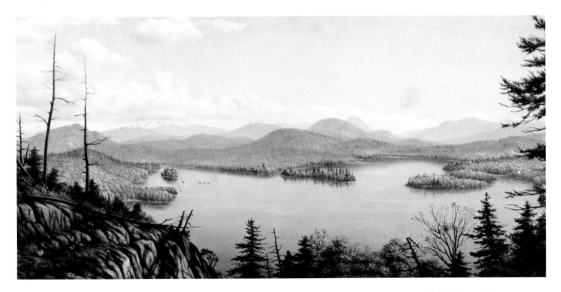

FIG. 9 *L. W. Prentice*, Lake Lila in the Adirondacks. *Checklist no. 26. Collection The Shelburne Museum.*

landscape and prevent a foothold. Although the forest is considerably denser, the scene appears much the same today as it did when Prentice visited the sites he painted in the late nineteenth century. Mt. Frederica still commands a breathtaking view of Lake Lila and gives the same sense of awe that Prentice experienced over a hundred years ago.[53]

For a third version of Smith's Lake, *Lake Lila* (plate 19), Prentice lowers his viewpoint to the level of the lake where rocks on the bottom, near the shore, are visible through the shallow, clear water. A solitary, minute figure in a rowboat on the lake is completely overwhelmed by the expansive landscape where both living and dead trees abound and the mountain and lake predominate. Prentice emphasizes the broad, graceful curvilinear forms of the mountain range in his imaginative recasting of the subject. The artist, looking to the northeast, may well have painted the scene from the future site of Dr. Webb's Nehasane Lodge.

Prentice painted over seventy landscapes of the central Adirondack region, ranging in date from 1871 to 1890, all drawn from his four excursions into the mountains. Other known locales Prentice recorded in his Adirondack repertoire include: *Mud Lake, Adirondacks* (checklist no. 69), *Lake George* (checklist no. 65), *Round Lake from Ampersand Mountain* (checklist no. 74), *Princess Falls* (presumably Prentice Falls named by the artist in 1877, checklist no. 71),[54] *Forked Lake* (checklist no. 63), *Lake Placid* (checklist no. 66) plus a large number of canvases that are simply titled *Landscape*.[55] During the time he was traveling back and forth to the Adirondacks, from 1873–1877, Prentice painted other northern New York state areas, including at least six known paintings in the Thousand Islands (checklist nos. 98,102,108,113,135,137). *Launch on a Lake* (checklist no. 98) and *Pleasure Boats on a Lake* (plate 23) both represent the steamboat activity to the popular St. Lawrence River resort area.[56]

Also a highly-skilled craftsman, Prentice made all his own ornate frames from plaster molds, the velvet-lined shadow boxes in which he placed many of his paintings, his easels, stretcher frames, palettes, brushes, and palette knives. He gilded all of his frames and even made the brass name plates that he engraved himself and attached to them. He accepted commissions solicited via the *Syracuse Journal*, held solo exhibitions, sold work and taught painting classes out of his studio.[57] Prentice supplemented his living made from his art by painting parlor ceilings, building houses, and making furniture. He could have learned these trades from his father and brothers, Albert and Franklin, who were a cabinet maker and machinist, carpenter, builder and gilder, respectively.

ADIRONDACK & OTHER LANDSCAPES

PLATE 1

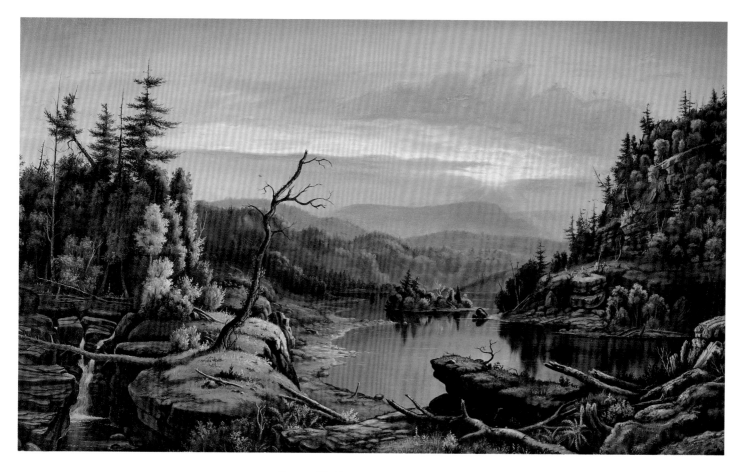

River Valley Landscape 1871
Oil on canvas 36 x 60. Private Collection. Checklist no. 42.

PLATE 2

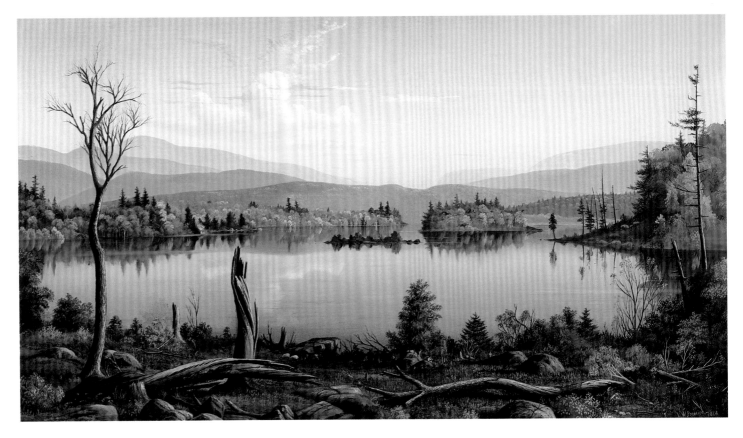

Blue Mountain Lake, Adirondacks 1874

Oil on canvas 30 x 54. Collection Richard J. Fay. Checklist no. 19.

PLATE 3

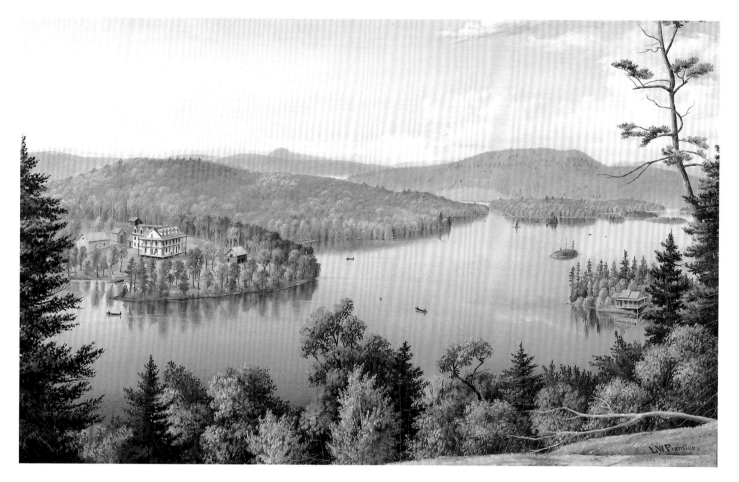

Blue Mountain Lake with Ordway House ca. 1878

Oil on canvas 15 x 24. Collection Donald and Ann Jones. Checklist no. 20.

PLATE 4

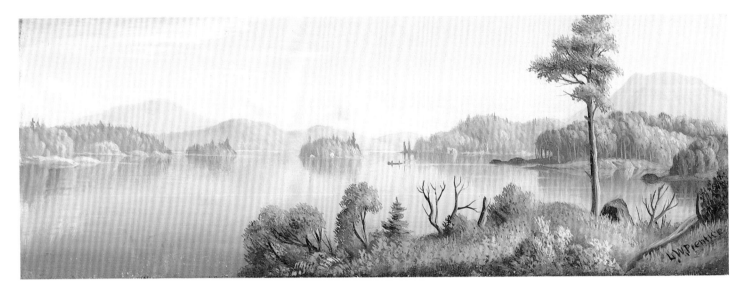

Big Tupper Lake, Mt. Morris in the Distance
Oil on canvas 4 x 11. Collection Albert Roberts. Checklist no. 16.

PLATE 5

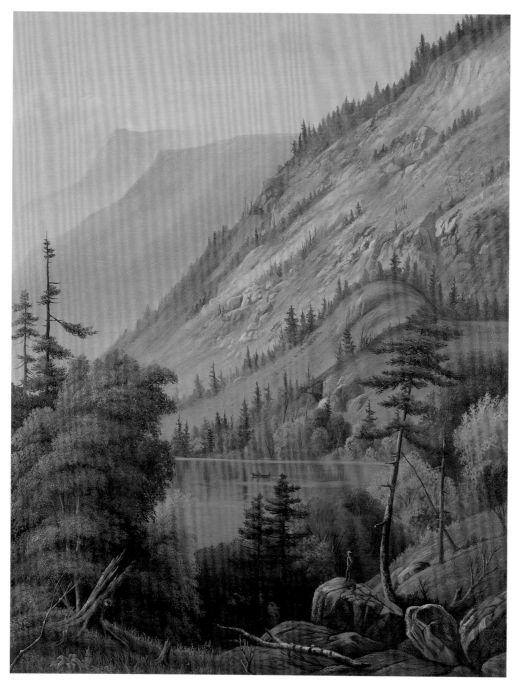

Adirondack Scene
Oil on canvas 35 x 44. Collection Onondaga Historical Association. Checklist no. 10.

PLATE 6

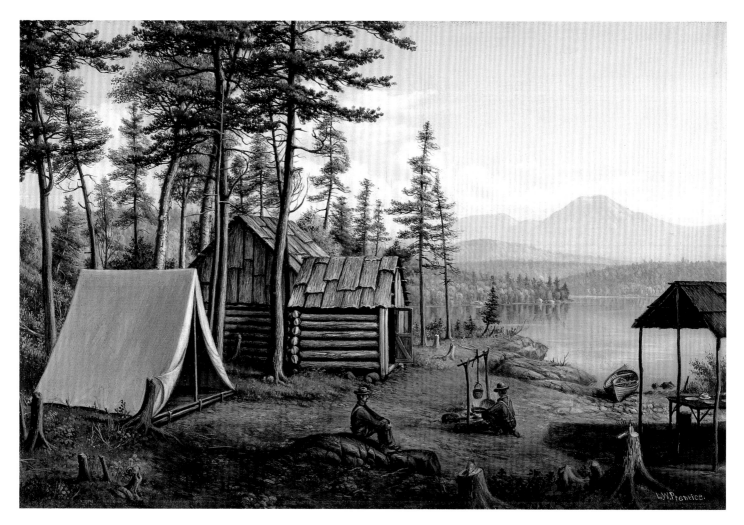

Camping by the Shore
Oil on canvas 12 x 18. Collection Adirondack Museum. Checklist no. 21.

PLATE 7

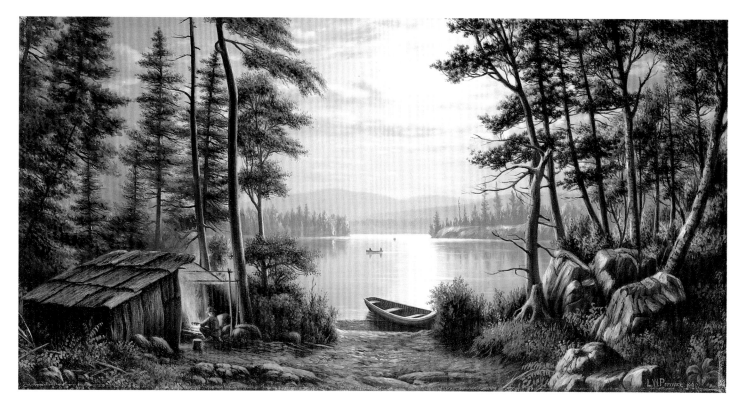

Moonlight Camping at Schroon Lake 1890

Oil on canvas 12 x 23. Collection Richard J. Fay. Checklist no. 30.

PLATE 8

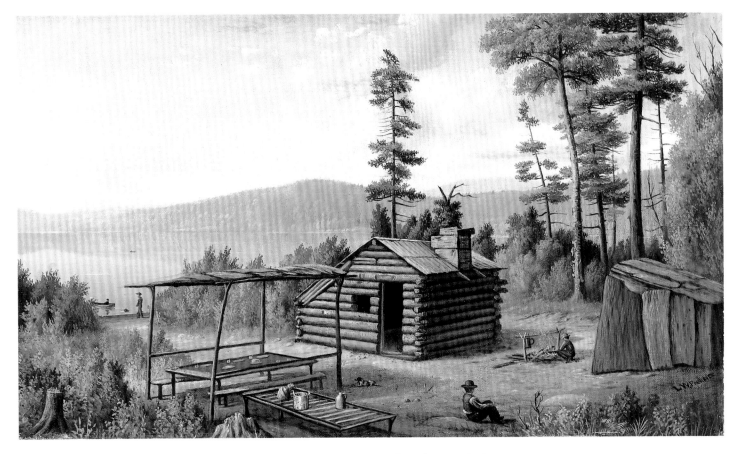

Watertown Camp, Albany Lake, Adirondacks, N.Y.
Oil on canvas 11 x 19. Collection Lynn H. Boillot. Checklist no. 50.

PLATE 9

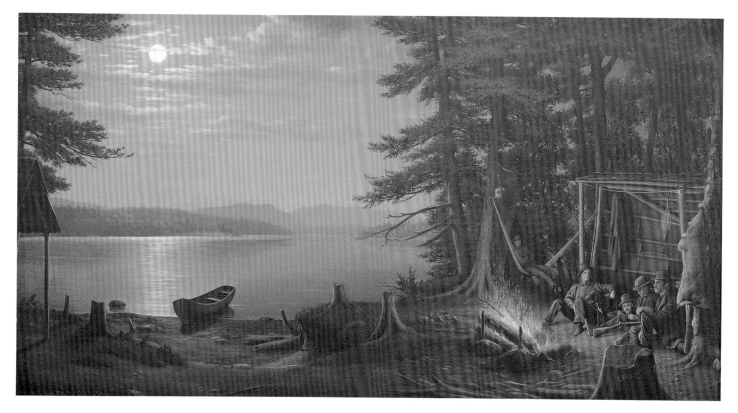

After the Hunt 1879
Oil on canvas 17 x 31. Collection William B. Ruger. Checklist no. 14.

PLATE 10

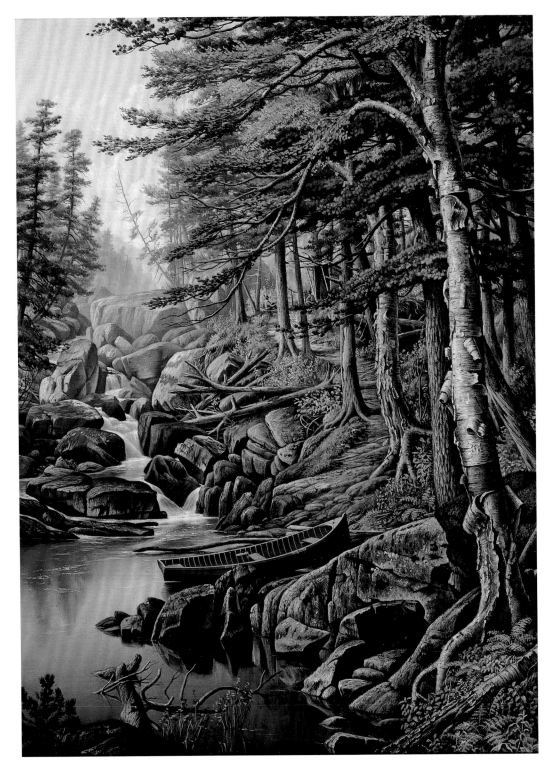

Moose River, Adirondacks 1884
Oil on canvas 30 x 22. Collection Richard J. Fay. Checklist no. 31.

PLATE 11

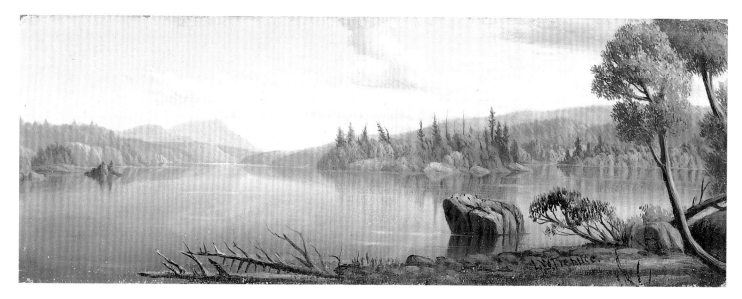

Rac [sic] *Lake*

Oil on canvas 4 x 11. Collection Albert Roberts. Checklist no. 34.

PLATE 12

Raquette Lake

Oil on canvas 11 x 19. Collection Adirondack Museum. Gift of Huntington Memorial Camp
(Camp Pine Knot). Checklist no. 36.

PLATE 13

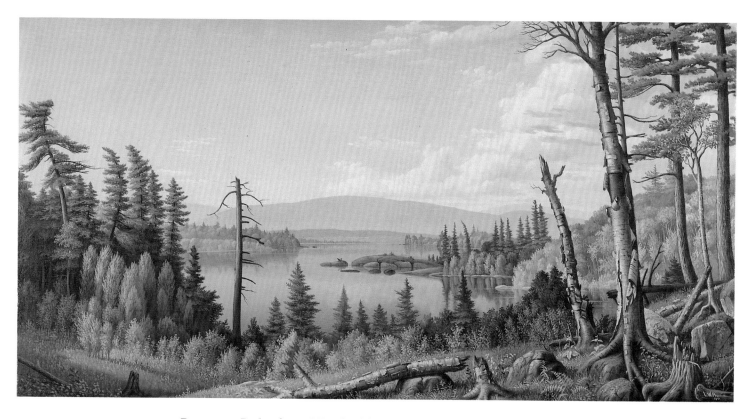

Raquette Lake from Woods Clearing, Adirondacks, N.Y. 1877
Oil on canvas 26 x 50. Collection Gilbert Butler. Checklist no. 38.

PLATE 14

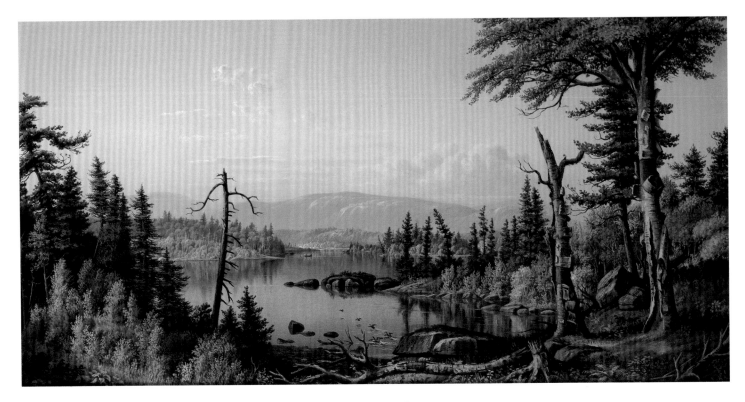

Raquette Lake
Oil on canvas 18 x 35. Collection John C. Wunderlich. Checklist no. 37.

PLATE 15

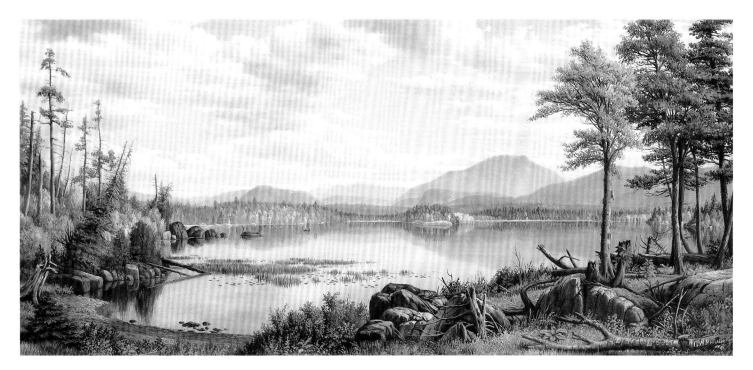

Raquette Lake—The Start of Autumn 1889
Oil on canvas 13 x 28. Collection Walter and Lucille Rubin. Checklist no. 40.

PLATE 16

White Birches of the Racquette [sic]

Oil on canvas 30 x 25. Collection Adirondack Museum. Gift of Mrs. Franklin Kent Prentice,

Jr., in memory of Franklin Kent Prentice, Jr., artist's nephew. Checklist no. 51.

PLATE 17

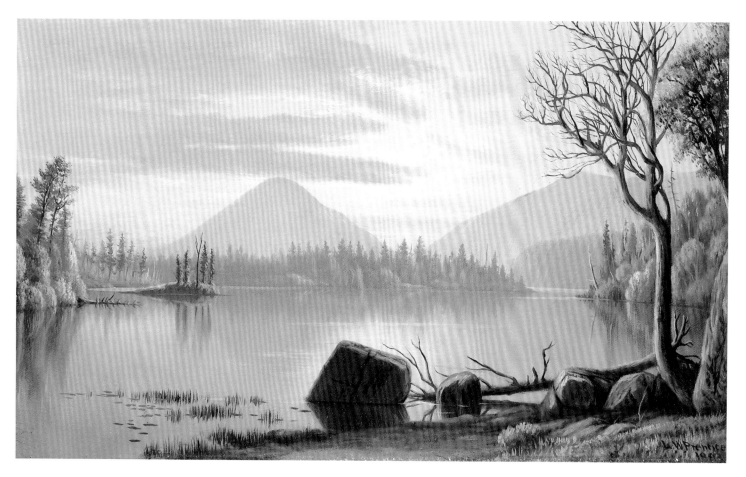

Sunrise on an Adirondack Lake 1883
Oil on canvas 9 x 15. Collection Richard J. Fay. Checklist no. 46.

PLATE 18

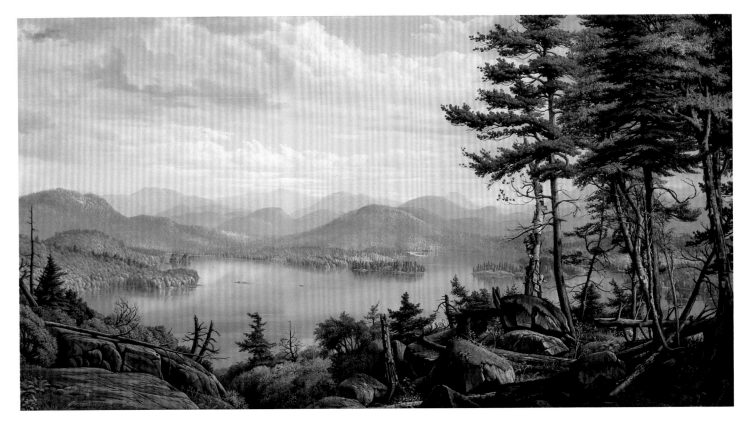

Smith's Lake, Adirondacks, N.Y. 1883

Oil on canvas 26 x 48. Collection Adirondack Museum. Gift of Mr. and Mrs.

Harold K. Hochschild. Checklist no. 45.

PLATE 19

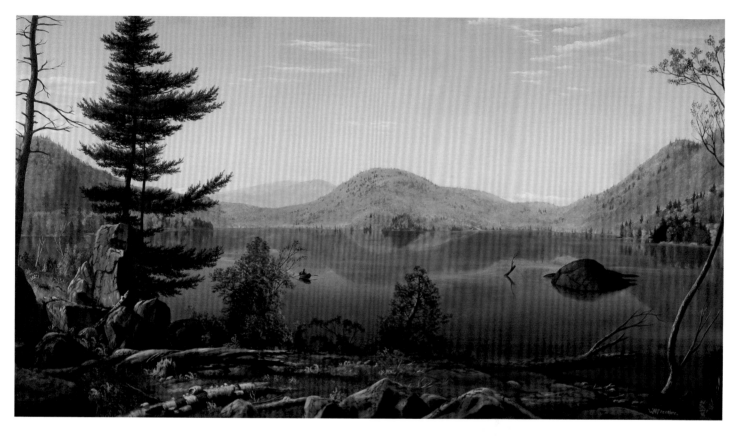

Lake Lila

Oil on canvas 33 x 57. Collection Mrs. John Davies Reed. Checklist no. 25.

PLATE 20

Adirondack Scene

Oil on panel 10 x 5. Collection Herschel and Fern Cohen.

Checklist no. 11.

PLATE 21

Landscape ["Mull Pond"]

Oil on canvas 11 x 9. Collection Charles F. Flanagan. Checklist no. 28.

PLATE 22

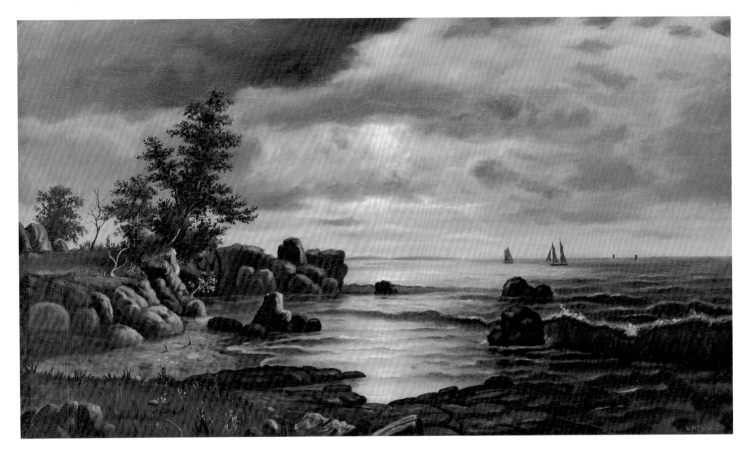

Seascape
Oil on canvas 24 x 42. Collection Kenneth and Ruth Rhodes. Checklist no. 105.

PLATE 23

Pleasure Boats on a Lake

Oil on canvas 26 x 48. Masco Collection. Checklist no. 102.

PLATE 24

Hopper's Gorge, Onondaga Valley
Oil on canvas 30 x 22. Collection Everson Museum of Art, Syracuse, N.Y., Purchased with funds
from the J. Stanley Coyne Foundation. Checklist no. 83.

PLATE 25

South of Sherburne on the Chenango 1875

Oil on board 43 x 72. Collection Roberson Museum and Science Center. Checklist no. 106.

PLATE 26

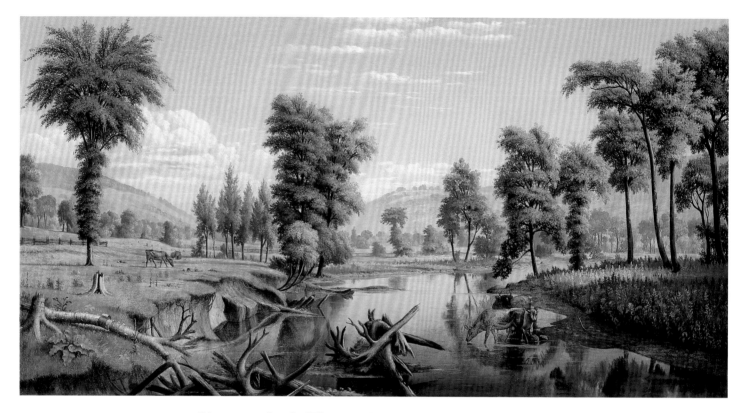

Chenango Creek, Three Miles North of Sherburne, N.Y. 1877

Oil on canvas 26 x 50. Collection H. J. Swinney. Checklist no. 80.

PLATE 27

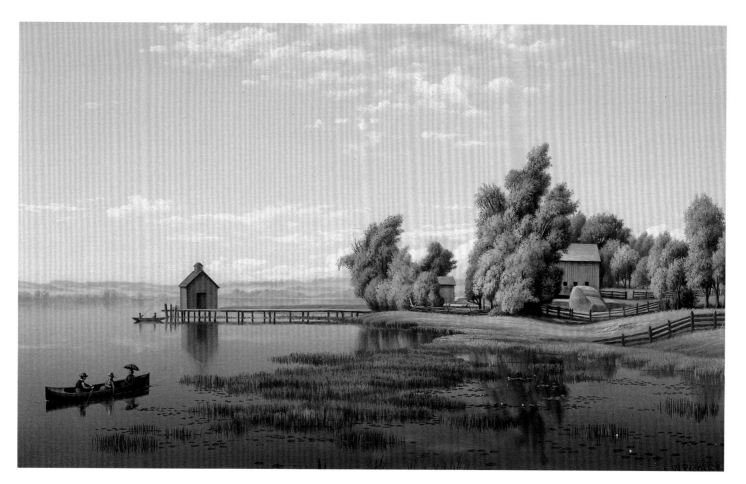

Niagara River at La Salle 1881

Oil on canvas 12 x 18. Collection Mr. and Mrs. Robert G. Donnelley. Checklist no. 99.

PLATE 28

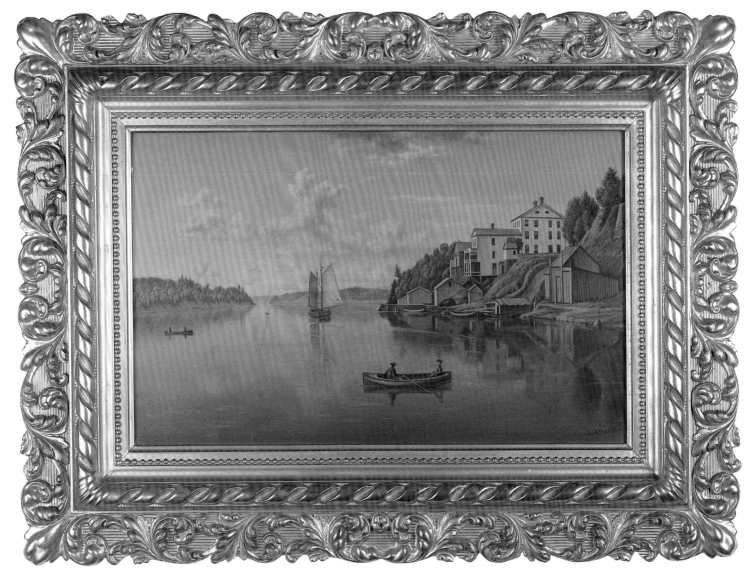

Landscape
Oil on canvas 15 x 20. Collection Mr. and Mrs. John Bishop. Checklist no. 92.

PLATE 29

Pine Trees along a Deserted Road
Oil on canvas 12 x 16. Collection Mr. and Mrs. Kenneth Bower. Checklist no. 101.

PLATE 30

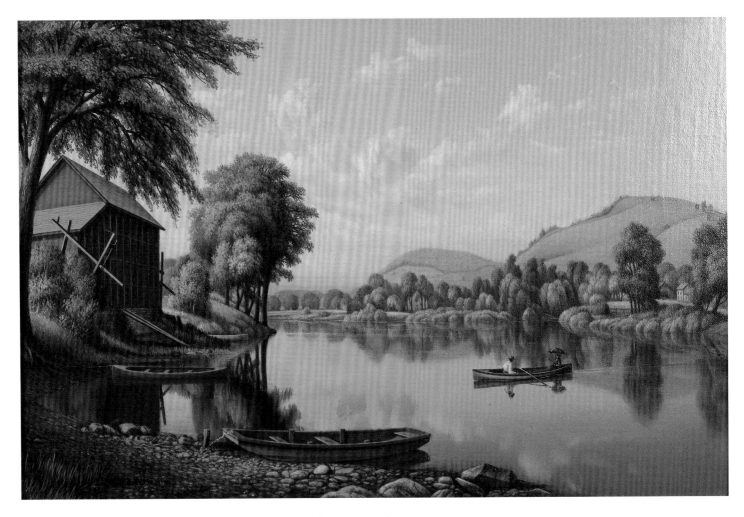

A Summer Romance

Oil on canvas 12 x 18. Collection Mrs. James F. Chace. Checklist no. 107.

PLATE 31

Landscape of Country Estate and Vineyards
Oil on canvas 10 x 18. Private Collection. Checklist no. 93.

PLATE 32

The Gorge at Letchworth Park

Oil on canvas 14 x 22. Collection Naomi's Art, Inc., New York. Checklist no. 82.

Although Prentice concentrated his artistic efforts on the Adirondacks and northern New York State during the 1870s, the central New York landscape surrounding Syracuse also served as a subject for the artist. His finely detailed painting of *Hopper's Gorge, Onondaga Valley* (plate 24), just outside the city limits, shows the popular nineteenth century picnic spot noted for its large boulders. The massive one depicted in the center of the composition—slightly obscured by pine trees, branches and other boulders—is called Devil's Tooth. Portrayed by the artist over a hundred years ago, this secluded and unspoiled site remains much the same today; Prentice gives us a glimpse of the natural landscape available on the outskirts of an urban environment.[58] In addition, he painted scenes of the Onondaga Indian Reservation (location unknown, checklist no. 117) and *Onondaga Creek, above Syracuse, N.Y.* (checklist no. 100). His other untitled paintings depicting central New York's pastoral landscape, with cows wading in a river or idly grazing in a field, represent the artist's continued inspiration drawn from the area where he lived for almost ten years (checklist nos. 81,85,88,91,95,109,131).[59]

Prentice traveled to Sherburne, New York, a bucolic community about seventy miles southeast of Syracuse, and a summer resort attractive to artists in the nineteenth century. The nearby Sulphur Springs, thought to be of medicinal value, attracted people to the area from as far away as New York City.[60] While there, Prentice painted at least two known canvases with similar titles: *South of Sherburne on the Chenango*, of 1875 (plate 25), and *Chenango Creek, Three Miles North of Sherburne, N.Y.*, of 1877 (plate 26). The 1875 painting might have had as its prototype an unlocated painting called *Sunday in the Afternoon* (checklist no. 136), highly praised by the *Syracuse Journal*, on both November 26 and December 2, 1873, as the artist's "most noteworthy of all" and a "masterpiece." The latter article read:

> The painting itself would suggest its name, so quiet are the scenes both on land and water. The steeple of the village church stands up from the valley as if to teach the woodland scene that the march of civilization is onward, and upon the languid river floats a skiff bearing a trio of people who are resting from their labors and hardly knowing whether to visit the church or the pleasant grove. The artist's imagination is displayed with fine effect, and the most delicate tintings on water, ground, and foliage, attest the expertness of

his brush. There is a happy blending of the real with the imaginary, and the effect upon the senses is highly pleasing. The picture becomes at once a study, and the greater the application of the scholar, the greater the pleasure he derives.[61]

The subject of *South of Sherburne on the Chenango*—three figures in a skiff "resting from their labors," the steeple of the village church and the pleasant grove—closely resembles *Sunday in the Afternoon* as described above, although, in all probability, Prentice rearranged like elements to suit his imagination, or at the request of a potential buyer for the 1875 depiction. Prentice's *Chenango Creek*, on the other hand, although similar in subject matter to the above paintings, shows only a few contented cows wading and grazing along the Chenango River several miles north of the village.[62]

In 1879, Prentice moved to Buffalo, New York, where he listed his occupation in the city's street directory as "artist." He was joined by his father Samuel and his mother Rhoda in 1880, and in 1882 he married Emma Roseloe Sparks of England.[63] (Years later, while living in Brooklyn, Emma Prentice gave birth to two children, a son, Leigh Wells, on March 22, 1887, and a daughter, Imogene, on September 17, 1889.) By 1883, his brothers Albert Duane and Franklin Kent were living in the Buffalo area as well.[64] Why did Prentice and his entire family move to Buffalo when he was held in such high regard as an artist in Syracuse? The answer may lie in the Syracuse real estate records which indicate that the family home at 16 Johnson Street was sold, under foreclosure proceedings, for taxes due on March 27, 1879, and that the family's taxes had been in arrears since 1877. Prentice and his family probably thought Buffalo would provide them greater employment opportunities.[65] Because of the artistic activity in Buffalo in the second half of the nineteenth century, Prentice may have felt that he would enjoy the same reputation as an artist there as he had in Syracuse. In addition, he may have been drawn to the area by the reputation of the artist Lars Gustav Sellstedt (1819–1911) and the Buffalo Academy of Fine Arts, although Prentice was not a member nor did he exhibit with the Academy.[66] He did, however, participate in an exhibition sponsored by the Social Art Club of Syracuse in 1882.[67]

While living in western New York, Prentice made sketches for three paintings of Niagara Falls (location unknown, checklist nos. 125, 126, 127), two of which are dated 1884, in addition to paintings of *Buffalo, N.Y.* (location unknown, checklist no. 110), *Niagara River at La Salle* (plate 27), and *The Gorge at Letchworth Park* (plate 32). Though

undated, this last work was presumably painted while the artist was in Buffalo between the years 1879 and 1883, as it would have been a fairly easy excursion from the city to the famous gorge at Letchworth State Park, about an hour's drive today. Prentice depicts only a portion of the picturesque and sublime gorge rising on either side of the Genesee River as it flows into the open, flat, western New York landscape. The artist overly simplified and stylized the natural formation of the stony gorge, delineating each heavily striated level, each fissure and crack. The canvas is made up of high-key (even garish) colors of acid green, bright orange and yellow that were definitely not local colors. We view the subject through the artist's eyes; his personal translation of a particular locale is at once recognizable yet not easily defined as "realistic." The chromatic intensity of this and other compositions recall the Pre-Raphaelite palette as well as the heightened coloration of chromolithographs that were so prevalent at the time. Prentice's graphic linearity and clear separation of color and form make his paintings particularly well-suited to the chromolithographic reproduction process and account for their highly decorative quality.

Prentice also continued to paint Adirondack subjects while he lived in Buffalo, although it is not known whether he made trips to the North Woods during those years. *Smith's Lake, Adirondacks, N.Y.* (plate 18) of 1883 was painted during Prentice's Buffalo years, but no press accounts of his artistic activities there are available.

BROOKLYN TRANSITION

Prentice and his new wife Emma remained in Buffalo for only four years before moving to Brooklyn in 1883.[68] It was an exciting time to arrive in that city, just prior to the celebrated opening of the Brooklyn Bridge on May 24. By 1889, his brothers Albert and Frank had followed Prentice east.[69] Brooklyn, in the early 1880s, had its own artistic identity and enjoyed an enthusiastic and active art community. The Brooklyn Art Club at 389 Fulton Street and the Brooklyn Art Guild at 201 Montague Street were two organizations available to artists living and working there. The Brooklyn Art Association, established in 1861, which held spring and fall art exhibitions, was, however, the primary support for innumerable artists.[70] Although the records of the Association indicate that Prentice did not participate in its semi-annual exhibitions, the Brooklyn Art Association offered him the opportunity to view the work of a great number of his contemporaries working in Brooklyn and the United States. Thomas Eakins was an instructor for the art school of the Brooklyn Art Association in 1883,

and William Merritt Chase conducted painting classes there from 1891–1895, although there is no evidence to suggest that Prentice participated in either artist's classes, nor did he assimilate aspects of either artist's style. In addition, special exhibitions such as "Fine Oil Paintings and Watercolors by Eminent European Artists," which brought the art of Europe to the artists and public in Brooklyn, were held in the Brooklyn Art Association rooms located at 172–174 Montague Street.[71]

According to the Brooklyn city directories, Levi, Levy or Lee W. Prentice lived and worked at six different addresses between 1883 and 1903. One work address of particular interest was 246 Fulton Street, the location of the Ovington Building at 246–252 Fulton, where Prentice and other artists rented studios on the top floor. Coincidently, the Brooklyn Art Association also rented space on the lower floors of the same building where it held art classes during the day. Prentice could hardly have been unaware of this artistic activity nor could he have helped having contact with the students and/or instructors of the art school.[72] Several members of the artist's family recall that Prentice operated a small but successful art school in Brooklyn around the turn of the century.[73] Since he was not listed as an instructor for the Brooklyn Art Association and because of his past teaching reputation in Syracuse, we can assume that he operated the school privately out of his own studio in the Ovington Building.[74]

Eager to embrace a new mode of expression that would allow him to continue to earn a living, Prentice began painting still lifes almost immediately after moving to Brooklyn, and that soon became his primary area of creativity. His earliest known still life painting is dated 1884. While he continued to paint the Adirondacks and other landscapes until 1894—it is conceivable that his reputation as a landscape painter followed him to Brooklyn and that he sometimes produced a landscape to satisfy a patron's wishes—still life painting dominated his artistic output during his twenty years in Brooklyn. Only fifteen dated landscape paintings of the 1880s and 1890s have been located (checklist nos. 2,15,30,31,35,39,40,43,45,46,49,88,89,94, 99); an undated painting of the Hudson River (checklist no. 116) and one entitled *Off Westpoint* (checklist no. 129) have not been found.

By the time Prentice arrived in Brooklyn in 1883, still life painting was an established and sought-after genre, as checklists of exhibitions held at the Brooklyn Art Association confirm. Once perceived as the lowest form in the hierarchy of worthy painting subjects, still life painting rose in prominence in the early decades of the nineteenth century, due primarily to the efforts of the Peale family in Philadelphia.

Charles Willson Peale's son Raphaelle (1774–1823) and his brother James (1749–1831) made significant contributions to the art of still life painting. Peale's other two sons and James' daughters continued the tradition throughout the century. By mid-century, several factors contributed to a renewed interest in the subject: the middle class began buying still life paintings as decorations for their homes; the American Art-Union exhibited and distributed them to the public; and foreign still life specialists, such as Severin Roesen, arrived from Germany. Chromolithographs made after still life paintings, published by Currier & Ives and Louis B. Prang, also played an important role in their dissemination. In addition, the Society for the Advancement of Truth in Art was active in New York in the 1860s, and *The New Path* (its literary voice) was supportive of still life as another truthful record of nature.

"One of the most distinctive aspects of Brooklyn painting in the late nineteenth century," wrote William H. Gerdts, "was the predominance of still lifes. This was no doubt due in part to the easy life that Brooklyn offered the sedentary painter, who could work within the comfort of his home and studio, often one and the same."[75] Leading still life painters active in Brooklyn while Prentice was there included William Mason Brown (1828–1898), August Laux (1847–1921), Joseph Decker (1853–1924), and the Granbury sisters, Henrietta (1829–1927) and Virginia (1831–1921), all of whom Prentice may have known and whose work he could easily have seen exhibited at the Brooklyn Art Association or the National Academy of Design. Prentice, himself, was not a member of either organization.[76]

STILL LIFE TABLEAUX

Prentice painted four types of still lifes: simple tabletop arrangements of fruit (or vegetables) set in an undefined interior; more elaborate tabletop arrangements in an identifiable interior; fruit seemingly uncomposed in the landscape under a tree; and living fruit, still attached to a bough or bush, growing outdoors in its natural setting. While the artist occasionally painted flowers (plate 49 and checklist nos. 196, 239), the majority of his still life subjects are fruit artificially arranged on a tabletop or other surface that is either highly reflective, marred with scratches and gouges or covered with a decorative cloth or placemat. He portrayed every fruit available to him: apples, strawberries, peaches, plums, raspberries, cherries, muskmelons, pears, currants, pineapples, gooseberries, grapes and bananas (listed in order of frequency of depiction).

Prentice's obsession with details and his thoughtful arrangement of elements in his still lifes carried over from his careful study of the natural landscape, as he approached still life painting in much the same manner. He was equally proficient at both, and the formal qualities intrinsic to his style—intensity of color, rigid linearity of objects depicted, variations in texture and repeated use of common elements—are evident in the two forms of painting. His still lifes have the same decorative quality as his landscapes. The only difference between them is that the still life objects he selected were always available to him as a reference, allowing him to be even more precise and accurate. He painted in front of his interior arrangements, whereas in his landscapes, he made oil sketches out-of-doors which he later transferred to canvas. During the transfer process, specific details were oftentimes altered, if not changed altogether. Prentice did not waver in his approach to still life painting. As he did in his landscapes, the artist concentrated on the motifs and the finely-tuned style he excelled at and was obviously comfortable with. In both his chosen modes of expression Prentice was a nonconformist, remaining true to his hard-edged realism, which effectively went out of style in the 1880s, with the influence of European Impressionism on so many of his contemporaries and a younger generation of American artists.

Prentice's still life paintings share certain stylistic affinities with the early pioneers of the subject, including Raphaelle and James Peale, John Johnston (1753–1818), John Francis (1808–1886) and his fellow Brooklynites mentioned above. His simplified arrangements were similar to those of the Peales and Johnstons, although Prentice did not concentrate on the timeless beauty of his subjects. He depicted them, instead, with all their natural flaws. In this sense his work can be allied even more closely with Brown's and Decker's, not only in choice of subject matter and modes of depiction, but because all three artists turned abruptly from painting landscapes to still lifes when they lived in Brooklyn. Their still life paintings were also literal depictions of carefully rendered fruit simply arranged in an unspecified interior, or out-of-doors in a natural setting.

William Mason Brown, the oldest of the three, may have had a direct influence on Prentice. He had been painting still lifes since the 1860s; his work was well-known in Brooklyn by the time Prentice arrived there, and his still lifes were widely available in chromolithographs.[77] Prentice's painting, *Raspberries on a Leaf* (location unknown, checklist no. 266), closely resembles one of the same subject painted by Brown; his *A Basket of Cherries* of 1897 (location unknown, checklist no. 249) depicts cherries spill-

ing from a basket similar to the one that Brown included in his *Cherries and Flowers*. Prentice's basket is also identical to one that Virginia Granbury used in her painting of *Cherries in a Basket*, an indication of either mutual inspiration or unabashed imitation.

Joseph Decker turned from painting landscapes in the 1870s to still life compositions in the 1880s. His early still lifes portrayed fruit in its living state, still hanging and ripening on the bough, such as *Green Apples* (fig. 10) ca. 1883, composed of fruit, leaves and tree branches densely compacted into an extremely shallow space. Decker's paintings represent such a tightly cropped segment of the apple tree that there is

FIG. 10 *Joseph Decker,* Green Apples. *Oil on canvas 20 x 30. Collection Coe Kerr Gallery and Berry-Hill Galleries, New York.*

hardly space for the volumes of fruit to exist. Although they espouse Ruskin's ideals that the subject should be presented in its natural state, Decker's fruit paintings do not provide a sense of the real object. Every apple is identified and clearly delineated, but its painterly quality, the artist's elimination of any illusion to three dimensions, and the fruits' "hardness" brought Decker less than favorable reviews from art critics of the period.[78]

Prentice's still lifes are far more three-dimensionally illusionistic than Decker's and possess the same sharply focused realism of his Adirondack and other landscapes. This heightened reality allies Prentice with trompe l'oeil still life specialists William Michael Harnett, Frederick Peto and John Haberle. Even Harnett, who deceived the

eye of the viewer with his complex arrangements of man-made objects, painted simple still lifes of fruit and vegetables early in his career (fig. 11).[79]

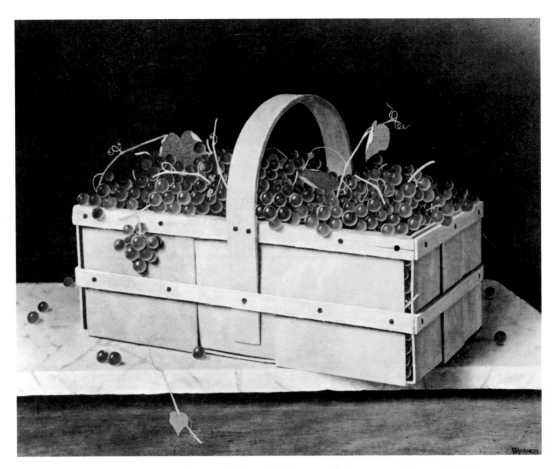

FIG. 11 *William Michael Harnett,* Basket of Catawba Grapes. *Oil on canvas 28 x 22. Collection The Charles and Emma Frye Art Museum.*

STILL LIFE ON A TABLETOP

Prentice's favorite still life subject was the apple. He depicted both interior and exterior views of that particular fruit in myriad ways: in a tin pail, in metal or silver bowls; in a paper bag; in and spilling out of bushel baskets, quart containers, or woven baskets; in felt and straw hats; nestled in a group under a tree, next to a ladder, a fence, a barn, or hanging on a bough. At least forty paintings of the subject are known to exist.

A simple composition of ordinary, everyday objects, *Apples in a Tin Pail* of 1892 (plate 33) consists of an overflowing tin pail of apples, the lid of the pail (cropped in half behind the pail), a metal bowl (also cropped at right) on a partially defined wooden tabletop or countertop placed before an unadorned background. It is the artist's most widely-known still life.[80] The space Prentice allotted for the apples and related objects on the table is shallow, just deep enough to sufficiently contain all of them. Prentice crops the image, as he did in the majority of his landscapes, to suggest that this composition continues on both sides. Set close to the picture plane and situated almost exactly at the center of the composition, the apples and the tin pail form a pyramidal design. Apples serve as all three points of the triangle, but the expected symmetry achieved by this arrangement is upset by the over-crowded right-hand side of the composition that includes three apples, the pail lid and the partially-filled bowl, as opposed to the left side which contains only two apples. Prentice attempts a trompe l'oeil deception in this picture to create the illusion of a real three-dimensional space on a two-dimensional plane.

The artist has provided every detail of the apples—their irregular shapes, dents, bruises, scuffs and scratches, worm-holes—and their intense two-tone coloration of yellow and red. William H. Gerdts made note of Prentice's tendency to report exactly what he saw: "A characteristic peculiar to Prentice is a rustic unpretentiousness. His fruit is brilliantly colored but often pitted with spots or holes."[81] Prentice further enhances this illusion with his careful rendering of the highly-polished pail in which the apples and bowl are reflected. Even the distortion of the apples in the curvilinear form is recorded. The foreground of the painting, however, is not reflected; instead of the artist painting the still life that we expect to see, Prentice provides only a fuzzy image. The simple pail, every detail of it, is clearly defined; the soldered seam, the rim, and metal attachment for the handle are all deliberately rendered in sharp focus. Prentice sets up a series of contrasts here: the warmth of the red and yellow apples and golden tone of the wooden table against the cool grey of the pail and olive green of the background; the hardness of the metal surface against the softness of the fruit. In his recreation, on canvas, of identifiable elements from the real world, Prentice suggests the temporality and imperfections in nature, as opposed to idealizing its natural bounty.

Prentice repeatedly incorporated many of the same objects when composing his different still life arrangements. *Apples in a Tin Basin* (checklist no. 155) depicts the same metal bowl that is just visible at right in *Apples in a Tin Pail*, and the bowl is

again shown containing another fruit in *Peaches in a Silver Bowl* (checklist no. 203). The paring knife in *Apples in a Tin Basin* also appears in the latter painting and in another *Still Life with Pears, Peaches and Grapes* (checklist no. 227). The same brown hat filled with apples and set in the landscape is shown in two known versions (fig. 12, checklist no. 153). The paper bag in *Bag of Apples* (plate 34) contains raspberries when it is reused a second time in *Bag of Raspberries* (location unknown, checklist no. 244), strawberries when he recycles it a third time in *Bag of Strawberries* (location unknown, checklist no. 245) and holds apples again in a fourth painting when it is depicted with melons in *Reflecting Apples and Melons* (location unknown, checklist no. 267). The artist consistently portrayed the fruit's blemishes, and he always combined it with common, everyday objects and utensils. No ornate crystal decanters, no shiny brass plates materialized from his palette, only simple baskets, bowls and metal containers that could be found in any household kitchen.

While all of Prentice's still life arrangements share the photographic trompe l'oeil effects of Harnett, not all of them project into our space, beyond the picture plane, which was a technique perfected by the latter artist. A few of those that effectively do

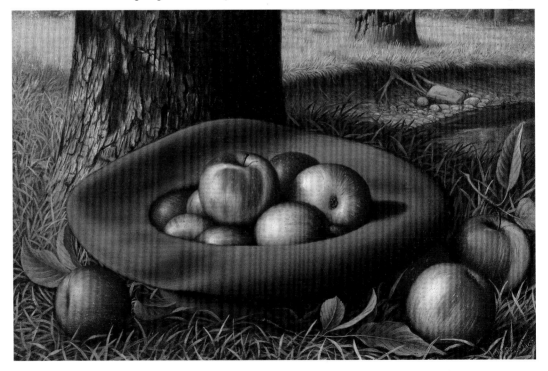

FIG. 12 *L. W. Prentice*, Apples in a Brown Hat. *Checklist no. 152. Private Collection. Photograph courtesy D. Wigmore Fine Art, Inc., New York.*

include *Cherries and Raspberries in a Basket* (plate 35), *Still Life with Berries* (plate 36), *Melons, Peaches and Pineapple* (plate 37) and *Peaches in a Basket* (plate 38). The latter painting also shows a fly, meticulously rendered on one of the peaches. Several of the artist's relatives recall that Prentice included a fly in a number of his compositions, remarking that they always tried to brush it away.[82]

In his more elaborate interior still life compositions, Prentice often combined strawberries, blue-and-white porcelain bowls, a cream pitcher, ginger jar, teacup and piece of tea cake in preparation for afternoon tea. *Still Life with Strawberries* (plate 39) and *Strawberries and Cream* (checklist no. 236) are perfect examples of the artist's repeated use of the exact same objects rearranged to create different compositions, a technique he perfected earlier in his landscapes of Raquette, Blue Mountain and Smith's Lake. *Afternoon Tea with Strawberries* (checklist no. 141), *Strawberries* (checklist no. 234) of 1898, *Strawberries and Iced Cake* (location unknown, checklist no. 276) and *Willowware and Strawberries* (checklist no. 240) also contain blue-and-white porcelain china but of different patterns. Prentice never painted a still life that included both an interior and exterior view, as John Francis did on occasion, although the former often alluded to the outdoors by his inclusion of a leafy branch or a variety of wooden baskets used to collect fruit. In at least one known still life, *Tea, Cake and Strawberries* (plate 40), Prentice made an emphatic reference in this regard by including one of his own landscape paintings, probably of central New York in the 1870s, hung above the fireplace behind a table set with strawberries, tea cake and a variety of willowware.

Fish and game were other popular subjects being painted in the second half of the nineteenth century. A. F. Tait painted wildlife, fish and hunting pictures throughout his career; and, in addition to landscape compositions of the Adirondacks, Catskills and New England, Winslow Homer painted sporting pictures of deer hunting and trout fishing, as well as two hanging trout still lifes. Prentice chose fish as his subject for only a few known still lifes, but he did not paint them as "game" pictures. Neither did he paint them in action out-of-doors or as sporting trophies as did Tait and Homer, or in a natural setting like Walter M. Brackett (1823–1919) or Samuel Marsdon Brookes (1816–1892), or together with all the gear that related to the sport as Harnett, Peto and others chose to. He depicted them, instead, as pure "nature morte." Prentice painted striped bass, pollock, a lobster and a bunch of radishes in *Fish, Lobster and Radishes* (plate 41) and at least three identical compositions of a single lobster lying on a marble tabletop. (checklist nos. 188,189,190).

Still Life with Oysters (plate 42), the fifth of the artist's seafood subjects, portrays

57

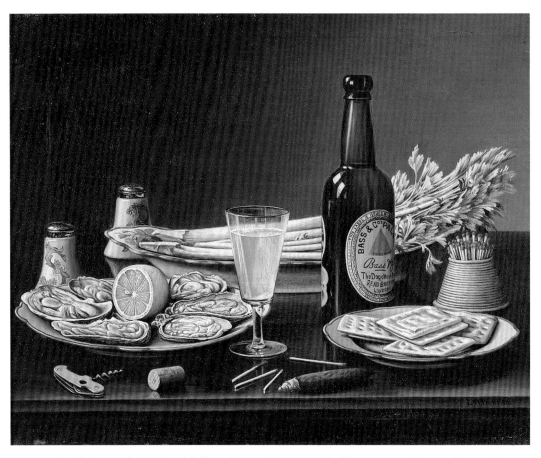

FIG. 13 *L. W. Prentice*, Still Life with Bass Ale and Oysters. *Checklist no. 217. Collection Mr. and Mrs. John A. Simkiss, Jr.*

an elaborate tabletop arrangement of hors d'oeuvres, consisting of a plate of oysters, a bottle of beer, a partially filled glass, a plate of crackers, a cork screw, a cork, a cigar, salt and pepper shakers, a seafood fork, a bunch of radishes and a small ceramic container filled with red-tipped matches. The complexity of this arrangement and the abundance of objects once again recalls the still lifes of John Francis. To achieve a completely balanced composition, Prentice distributed the color red evenly throughout, on the decorative salt and pepper shakers, the radishes and on the tips of the matches. As in his landscapes, Prentice consciously composed the objects in his paintings in order to lead the viewer into his picture. The loose matches at center (one of them burned), direct our eye into the scene to a second match which points to the lit cigar that in turn leads us to the left side of the composition. There, the cork screw and cork parallel to it draw our attention to the plate of oysters, which projects

into the shallow depth to the horizontal tray of celery that connects the glass, the salt and pepper shakers, the beer bottle, the bunch of radishes, the container of matches and the plate of crackers. This oblong pictorial organization then leads back to the cigar at the center of the composition. A second painting of the same subject, *Still Life with Bass Ale and Oysters* (fig. 13), portrays nearly all the same objects, but instead of a bunch of radishes obscuring the bottle's label, Prentice renders the Bass Ale label. The former painting was presumably the artist's second depiction of the subject, created for a patron who did not want to advertise that particular "Dog's Head" brand. Prentice's substitution of the red-and-white radishes for the red-and-white label underscores the color balance he was striving for throughout the painting.

Only four examples of Prentice rendering both the inside and outside of fruit are known to exist. *Melons, Peaches and Pineapple* (plate 37), *Melons* (checklist no. 191), and *Cantaloupe* (checklist no. 173) depict a muskmelon sliced open to expose the luscious, orange fruit inside, and *Peaches in a Basket* (location unknown, checklist no. 262) contrasts the roughly textured pit of the sliced peach with the smooth fruit inside.

STILL LIFE IN THE LANDSCAPE

Prentice painted two types of still life compositions set in the natural landscape. The most prevalent is an arrangement, differing slightly in format, of previously picked bushel baskets of apples or peaches. *Bushels of Apples under a Tree* (fig. 14) is situated in a landscape reminiscent of Prentice's Adirondack paintings, even to the unfurling birch bark. *Peaches in a Landscape* (plate 50) depicts the fruit arranged under a tree next to a river. In this painting, Prentice allows the viewer more than just a glimpse of the surrounding central New York landscape. The peaches, grass and tree trunk comprise the sharply focused foreground, the reflective river the middle ground, and the hazy trees, fence, and hilly landscape serve as the atmospheric background. Utilizing his compositional formula and systematic approach, Prentice effectively juxtaposes a studied still life and a landscape in one picture, much as he had repeatedly incorporated broken branches and blasted tree trunks in the foregrounds of his landscapes. Another painting, *Overturned Basket of Peaches and Landscape in Background* (checklist no. 195) exposes even more of the same landscape to the viewer than the previous picture, as well as a greater portion of the peach tree. So conscious was Prentice of every detail that he even painted a "halo" of fuzz for each peach depicted, in the manner of William Mason Brown. Mountains in the distance recall his Adirondack scenes.

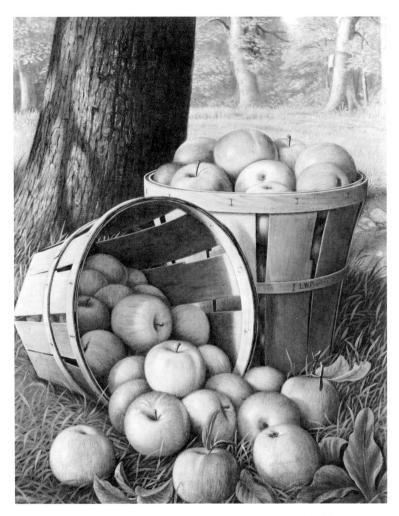

An Abundance of Apples (plate 51) is a sparkling example (still enclosed in its velvet-lined shadow box) of one of Prentice's finer still life compositions of previously picked apples set in the landscape. The brilliant red apples, strewn about the ground under a tree, are shown at every possible angle. Their color, complemented by the intensely green leaves and blades of grass, stands in sharp contrast to the subdued neutral grey tonalities of the tree trunk and brown earth. Each piece of fruit is clearly defined, covered with spots and bruises, and retains its own volume. The tree bark, every plant, leaf, blade of grass, and clover, are precisely rendered. In his series of fruit arranged in the landscape Prentice consistently paints only a portion of the tree

FIG. 15 *L. W. Prentice,* Landscape with Apple Tree. *Checklist no. 187. Private Collection.*

trunk, severely cropping it so that, from the artist's worm's-eye view, the tree achieves a surprising monumentality in relationship to the fruit lying underneath it. The disproportionate scale between the two elements alludes to a subject that Prentice showed an awareness of very early in his career, the giant Sequoia trees of the Mariposa Grove located near the end of the Mariposa Trail.

In his second type of still life situated in the landscape, Prentice owes a debt to the American Pre-Raphaelites' truth to nature doctrines in his depictions of unpicked fruit and flowers alive and growing on bough or bush out-of-doors. *Landscape with Apple Tree* (fig. 15) is one of four known still lifes representing apples growing on a tree

in their natural landscape, as opposed to picked apples in a basket or in an interior arrangement. It represents a nostalgic return to the similar landscape that he depicted in his earlier paintings of western and central New York; however, the tree trunk is no longer visible, only a cropped bough of apples projecting into the scene from the left is seen. This distinct plane of sharply focused apples and grassy knoll framing the scene compel the viewer along the reflective river that winds its way to the atmospheric hillside beyond. Prentice's placement of twelve apples on a bough at the very front of the picture plane is reminiscent of Decker's still lifes of the same subject, although Prentice's are far more dimensionally defined, and the apples' placement recalls, as well, the stereographic devices the artist incorporated in his landscapes.

Prentice's paintings of *Green Apples in a Landscape* (checklist no. 186), *Berries* (checklist no. 169), *Cherries on a Bough* (plate 56), *Bed of Strawberries with Monarch Butterfly* (plate 57), *Raspberry Bush* (plate 58), *Crabapples Hanging from a Tree* (checklist no. 178), *Ready for Picking* (checklist no. 209), *Strawberries Spilling from a Basket and Growing on a Bush* (plate 59), *Wildflowers* (checklist no. 239), *Pansies and Nasturtiums* (checklist no. 196) and *Flowering Plant against a Fence* (plate 49) represent the known still life compositions that demonstrate his use of Pre-Raphaelite devices.

It does not appear that Prentice enjoyed the same artistic success in Brooklyn that he did in Syracuse. He often bartered his paintings for services there with barbers, butchers and others, and he once paid back a loan with a group of his still life paintings.[83] He was not mentioned by Brooklyn's press, he did not exhibit there, nor were any of his paintings in prominent collections of American art of the period. Prentice was not forgotten in Syracuse, however. He received a line in the *Syracuse Standard*, June 10, 1894, in an article entitled "Painters of World-Wide Fame Who Have Lived in Syracuse" which read: "L. N. [*sic*] Prentice now of Brooklyn, who lived for a long time in [*sic*] Johnson Street, has made considerable of a reputation for his work in still life." The following year, James Cantwell, a fellow Syracuse artist, mentioned Prentice in his address to the ladies of the Onondaga Historical Association. Titled "Art in Onondaga County from an Artist's Standpoint," Cantwell's lecture revealed that "L. W. Prentice knew every birch tree in the valley and also how to paint them."[84]

Prentice's artistic activities are difficult to reconstruct between the years 1903—when he was no longer listed in the Brooklyn directories—and his death in Philadelphia in 1935. His name appears for the first time in the Philadelphia directory of

1905, but his years in that city remain sketchy.[85] We do know that Prentice underwent cataract surgery at Wills Eye Hospital in Philadelphia around 1923, at the age of seventy-two. From all reported accounts, that operation was successful and the artist continued painting until his death twelve years later. However, no Prentice still lifes or landscapes have been located dated after 1899. A portrait that has recently come to light is dated 1920, and would suggest that his cataracts were not severe enough to compromise his vision just three years prior to surgery. This full portrait of a woman is entitled *Afternoon Idyll* (plate 64) and depicts the woman relaxing on her porch, set before a landscape that is reminiscent of Prentice's central and western New York paintings of the 1870s and 1880s. We do not know who the woman is, but there has been some conjecture that she is the artist's wife Emma or perhaps his daughter, Imogene. She does not resemble, however, existing photographs of either Emma or Imogene Prentice. While the figure is rather awkwardly handled, Prentice carefully portrayed the sitter's facial features and dress. Documenting portraiture, landscape and still life, *Afternoon Idyll* is the only known example of the artist's work that incorporates all three of Prentice's chosen painting types in a single picture.

Since we do not see Prentice loosen his grip on his hard-edged style, he probably quit painting just prior to or with the onset of cataracts. Inconsistencies in some of his still life paintings, where fruit appears flatter and less volumetric, may have been due to his impaired vision. But, all in all, no large number of paintings has been found that show the debilitating effects of cataracts. Two landscapes (location unknown, checklist nos. 118,119) and one still life of apples entitled *Ready for Picking* (checklist no. 209) that appear sketchy and unfinished could have been painted late in the artist's life, after surgery, and may well have been his last works.[86] From information gathered from the artist's relatives, we also know that at the same time Prentice moved to Philadelphia, he built and maintained a small studio on the Trumbull County line near Bridgeport, Connecticut, across the street from his brother Albert's home. He reportedly spent the summer months and every Thanksgiving at this studio. *Above Beardsley Park, Bridgeport, Connecticut* (fig. 16) is the only known canvas that describes a portion of the surrounding landscape near his studio.[87] Prentice's grandniece, Alberta Prentice Poppe, recalling one of her summer visits in the late 1920s to her grandfather Albert in Bridgeport, said that her great-uncle Levi was not painting much after his cataract surgery but spent the majority of his time making frames for existing paintings. Mrs. Poppe assisted with the gilding of some of those

FIG. 16 *L. W. Prentice*, Above Beardsley Park, Bridgeport, Connecticut. *Checklist no. 78. Private Collection.*

frames. She also reported that, during one of her visits to Connecticut, Prentice painted a portrait of her, sitting on a rock, in the middle of one of his completed river scenes. This painting has not been located.[88]

Imogene recalled that when she was quite young, she and her family moved to New Jersey, which would account for the missing year between the artist's move from Brooklyn in 1903 and his arrival in Philadelphia in 1905. She maintained that her father sent her alone on a train with a number of his paintings to a destination she could not recall in New Jersey, where she waited until her mother and father arrived.[89] The same financial difficulties Levi and his parents had previously experienced in Syracuse might have precipitated his hasty departure from Brooklyn. In any event, the only known landscape that associates Prentice with New Jersey is *Pine Trees along*

a Deserted Road (plate 29), an image of the Pine Barrens, which he may or may not have painted while living there.[90]

Despite his relative anonymity after his departure from Syracuse and his concentration on still life painting upon his move to Brooklyn, at his death in Germantown on Thanksgiving Day, November 28, 1935, Prentice was eulogized primarily as an Adirondack landscape painter. His obituary in the Philadelphia *Journal of Commerce* read:

> As a landscape painter and interpreter of the best in American natural scenery, Mr. Prentice had few peers. He was known and honored wherever art is worshipped for his unusual talent in depicting the glorious lake and mountain beauty of the Adirondacks particularly. The passing of Mr. Prentice well may be universally mourned. The world at this time is in sad need of men of his calibre, men who worship at the shrine of truth and beauty and can look beyond the petty acquisitions of the day to scenes of grandeur and glory which will never pass away. Yet, though he is gone, his spirit and his works shall not soon let America forget him.[91]

Beyond his short-lived burst of fame in Syracuse in the 1870s, where he was praised as "an artist of world-wide fame," "master" and acknowledged as a "rare genius," for some thirty-five years after his death, Prentice was indeed forgotten. Yet, with the resurgence of interest in representational and realist subjects in the 1970s, his art, especially his still life paintings, began once more to be recognized. His collectors have referred to Prentice's paintings as "primitive," "surreal," and "magical." I would suggest, instead, that through his deliberate painting method, use of high key, exaggerated colors, minute detail, and emphasis on hard outlines, Prentice achieved something of a hyper-reality, or an extreme realism, that immediately engages the viewer. The appeal of the heightened realism of his work corresponded to a contemporary interest in that direction. Photorealists Audrey Flack's and Richard Estes' expertly crafted paintings after a photograph were popular in the early 1970s, reflecting their audience's interest in sharply focused realist subjects. For three preceding decades, Realism, as a style, had been usurped by the dominating styles of Abstract Expressionism, Pop, Op and Minimalism, among others.

Throughout his long and productive career, Prentice remained outside the artistic mainstream tradition, steadfastly committed to his two chosen modes of expression

of a well-ordered natural world. He chose his direction very early, all the while confronted with ongoing stylistic changes that were introduced and executed during his lifetime. He rejected the prevalent style of the American Impressionists in the late nineteenth and early twentieth centuries, and the European "isms" of Post-Impressionism, Cubism, and Fauvism introduced to America through the landmark Armory Show of 1913. He was not affected by early twentieth century modernists such as John Sloan and the Eight, or by the abstractions of Stuart Davis, George L. K. Morris and others.[92] Quite the contrary, he dedicated his life to the glorification and celebration of nature and art. "To the very core, he was a product of this new world, and it is this inherent love for the land, and deep sensibility to its beauty that seemed to lend his works their atmosphere of authenticity and realism."[93] Prentice was indeed a product of his own times, and created a product that was in demand, when people were experiencing a nostalgia for a disappearing world. Over a century later, confronted with excessive environmental pollution, the greenhouse effect, toxic waste, and deforestation, the public still yearns for the certainties of the past. Prentice's canvases are more than documentations of specific places and keenly-observed objects; to each depiction he added individual touches—his own vision of reality which was "a happy blending of the real with the imaginary" and adopted a personal form of expression that was his hallmark. Whether landscapes of the Adirondack mountains, rivers and hills of central and western New York, or still lifes of fruit, flowers, or fish, Prentice's paintings capture the quiet dignity of the natural world—nature permanently staged in time.

1. Edwin R. Wallace, *Descriptive Guide to the Adirondacks and Handbook of Travel* (New York: The American News Company, 1875), Addenda. The advertisement was carried in the next five consecutive editions of the *Guide* through 1880, which was about the time Prentice moved from Syracuse to Buffalo, New York, and discontinued traveling to the wilderness.

2. This "rush to the wilderness" was brought on in part by the publication, in 1869, of William H. H. Murray's *Adventures in the Wilderness* (Blue Mountain Lake, N.Y.: The Adirondack Museum and Syracuse University Press, 1989), a series of adventure stories as well as a practical guide which portrayed the region as a sportsmen's paradise and a cure-all for the unhealthy. In his *History of the Adirondacks*, Alfred L. Donaldson remarked that Murray's book "had a truly phenomenal success for a book of its kind. It displaced the popular novel of the day. Everybody seemed to be reading it, and a great many people were simultaneously seized with the desire to visit the region it described. The book was published in April—some say on the first—and by June there was an influx of tourists such as the Adirondacks had never seen before." *A History of the Adirondacks*, vol. I (Harrison, N.Y.: Harbor Hill Books, 1977), pp. 193–194.

3. According to Margaret (Peggy) Goodwin O'Brien, in her unpublished manuscript on artists in the Adirondacks, Adirondack Museum Library, Blue Mountain Lake, New York, hereafter cited as AML, Blue Mountain Lake.

4. The Adirondack Park was established in 1892.

5. John Ruskin's *Modern Painters* was first published in England in 1843 and was available in the United States by 1847. According to Imogene Prentice, the artist's daughter, her father had no formal art training. She said he copied other artists' work, and worked from reproductions and postcards. This information is verified by Prentice's grandniece, Alberta DeMere Prentice Poppe, granddaughter of the artist's brother, Albert, who remembers Prentice being quite proud of the fact that he was self-taught. During this time he could have received an art education at Syracuse University, in the College of Fine Arts, although University records do not indicate Prentice took advantage of that opportunity.

6. Other artists who lived on the Weiting Block, near Prentice, included the Misses Burt who opened a school of painting there in the 1870s. 16 Johnson Street was renamed and renumbered 147–149 Lincoln Avenue.

7. From the collections of the Onondaga Historical Association Research Library, Syracuse, New York, hereafter cited as OHA, Syracuse.

8. William H. Gerdts, vol. I, *Art Across America: Two Centuries of Regional Painting 1710–1920* (New York: Abbeville Press, Publishers, 1990), p. 186. In December 1876, an exhibition of over 300 engravings and etchings after such figures as Raphael, Poussin, Claude Lorrain, Durer and Rembrandt was sponsored by the Ladies Employment Society of Syracuse. In March 1877, the Social Art Club organized an exhibition that included artists William Trost Richards, David Johnson, Thomas Cole, Titian, Durer and Correggio. In May 1882, the same group put together an exhibition of 150 paintings that included Syracusans such as Prentice, his contemporaries James Cantwell, Henry Ward Ranger and Chester Loomis, as well as Rembrandt and other masters. OHA, Syracuse.

9. *Northern Christian Advocate*, 12 June 1873. OHA, Syracuse.

10. Lawrence Hotel registers in AML, Blue Mountain Lake. The hotel was located on the Herkimer and Lewis County line, on the fork of the North and South Branch of the Moose River, which led to Fourth Lake in the Fulton Chain of Eight Lakes.

11. The first public exhibition of Prentice's work, held from approximately January 21–23, 1873, was a single oil painting displayed in the front window of Kent and Miller's Clothiers at 18 South Salina Street in downtown Syracuse. Unnamed in the January 21 *Journal* announcement of the exhibition, Prentice was acknowledged only as "a young artist of our city." In the second report, on January 24, he was specifically cited as the artist who painted the view of "Yo Semite" [*sic*] on display in the clothier's window. OHA, Syracuse. According to Prentice's grand-

niece, Mrs. Poppe, Prentice painted portraits of the Vanderbilts, Rockefellers, and the Astors; however, no portraits of any of them have been located.

12. It is possible that the large painting may have been created at a later time, after the artist's first reported trip to the mountains, and dated only when it sold, at which time Prentice perhaps incorrectly recalled the date it was painted. It is also conceivable that this early painting could have been mistaken by the newspaper reviewer as a Yosemite scene, but it is unlikely, as the reporter seemed to have had direct contact with the artist, and why Prentice would refer to a subject that appears to be Adirondack as one of Yosemite Valley is unknown. If we are to accept the 1871 date, then this painting represents Prentice's "debut" as a landscape painter, two years prior to the *Syracuse Journal* announcement, and it supports the artist's even earlier interest in his native landscape, as it is dated only one year after he and his family moved to the city.

13. OHA, Syracuse. The reviewer's remarks on how "true to nature" the scene was, how "accurate" the artist's depiction, and that "close study is apparent" are interesting, since the artist did not personally see the scene. Guidebooks of the Yosemite Valley from the nineteenth century verify the existence of a trail named Mariposa, which led to the giant Sequoias in the Mariposa Grove. J. D. Whitney, State Geologist, *Geological Survey of California, The Yosemite Guide-Book* (California: Published by the Authority of the Legislature, 1874), pp. 80, 86 and on map opposite p. 84.

14. Prentice did not even move to Buffalo until 1879. The view of *The Mariposa Trail* that Prentice selected, as it was described in the newspaper review, did not include the giant sequoias that were photographed by Watkins on his second trip to Mariposa; instead, the artist is said to have portrayed the mountain pass of Mariposa "falling upon its rocky precipice," the colorful foliage with "more colors than the rainbow," the cascade of the falls and the "crystal clearness of the water" similar in content to the operatic images created by Bricher, Hill and Bierstadt. The scene is described as a serene and peaceful view, a picturesque vista rather than one that would carry with it a connotation of the sublime. One of Weed's photographs is specifically titled *The Valley, From the Mariposa Trail.* The painting subsequently sold to a resident of Syracuse for $1,000, a very high price for such a young and inexperienced artist. Nevertheless, this information provides a sense of the early success Prentice achieved in Syracuse, encouraging him to pursue his chosen mode of expression. In the same year that his first painting was exhibited and reviewed, real estate records show that Prentice purchased a house on Johnson Street in Syracuse for the sum of $4,500. William Cullen Bryant's book, *Picturesque America or The Land We Live In* (New York: D. Appleton and Company, 1872), which contained engravings of American scenery from all areas of the country, including the Mariposa Grove, was also available in 1872.

15. *Syracuse Journal*, 1 November 1873. OHA, Syracuse. The name listed just above Prentice's on the same day was a familiar one: E. R. Wallace.

16. Upon entering the mountains Prentice would have first encountered the eight lakes of the Fulton Chain. As he continued northward, he would next come upon Raquette Lake, Forked Lake, Blue Mountain Lake and Long Lake respectively. In order to reach all the lakes mentioned in the report, he would then travel west to Little Tupper Lake, Round Lake, Big Tupper Lake and Saranac Lake, that is, if he methodically traveled, as described, to each lake. His subsequent stay at the Lawrence Hotel in Moose River on October 29 suggests he may have made his trip in this circuitous manner.

17. *Syracuse Journal*, 2 December 1873. OHA, Syracuse.

18. The spiritual connections in Prentice's paintings were probably unconscious; however, his combination of close scientific accuracy with an atmospheric perspective further perpetuated the kind of painting preferred by the American public at mid-century.

19. *Syracuse Journal*, 24 January 1873. OHA, Syracuse.

20. Willliam Culp Darrah, *Stereoviews: A History of Stereographs in America and their Collection* (Gettysburg, Pa.: Times & News Publishing Co., 1964), pp. 50–57.

21. The firms operating in Syracuse included Gates & Malette, W. V. Ranger, Ranger & Frazee, and H. Lazier. Darrah, *The World of Stereographs* (Gettysburg, Pa.: Times & News Publishing Co., 1977).

22. Elizabeth Lindquist-Cock, The *Influence of Photography on American Landscape Painting, 1839–1880* (New York: Garland Publishers, Inc., 1977), p. 97.

Bierstadt, Church and Durand also used carefully studied and sharply focused natural objects in the foreground of their paintings in this manner.

23. Albert Bierstadt knew the photographs of Watkins and Muybridge well and also those of his brother, Charles Bierstadt, who accompanied him on several of his excursions west.

24. While it is not documented that Prentice traveled to the Adirondacks that year, at least six reviews in the Syracuse newspaper of 1874 indicated that the artist was completing paintings in his studio begun the year before. Prentice could have painted this view of the lake from a site just below Miles Talcott Merwin's Blue Mountain House, a small log cabin that Merwin built for himself in 1874, the year after Prentice's trip there. The cabin was situated on the west slope of Blue Mountain, 250 feet above the lake and one-half mile up the road from the hamlet of Blue Mountain Lake, on the road to Long Lake. Two years later Merwin built an auxiliary log cottage—also named the Blue Mountain House—which he opened as a hotel. That cabin accommodated up to forty guests who were charged $7.00 per week or $1.25 per day for room and board. In 1955, the original building was replaced by the main building of the Adirondack Museum. The auxiliary cottage, exhibited today on the museum grounds, was entered on the National Register of Historic Places in 1978.

25. It is not known just how detailed Prentice's sketches were, since they no longer exist, although they must have been quite finished, as he was able to reconstruct accurate enough documents of the sites he visited that they can be identified today.

26. OHA, Syracuse. In addition, that same review referred to a scene "from the Indian reservation looking Westward toward the Spafford Hills" and "a dozen or more small paintings by the artist." The "Indian reservation" is the Onondaga Reservation located south of the city. That painting has not been located.

27. *Syracuse Journal*, 2 December 1873. OHA, Syracuse.

28. Thomas Cole, "Essay on American Scenery," *The American Monthly Magazine*, New Series, vol. I (January 1836), pp. 1–12. Reprinted by John W. McCoubrey, ed., *American Art 1700–1960 Sources and Documents* (Englewood Cliffs, N.J.: Prentice-Hall, 1965), p. 98. For an in-depth examination of the relationship of nature and art in the nineteenth cen-

tury, see Barbara Novak, *Nature and Culture: American Landscape and Painting, 1825–1875* (New York: Oxford University Press, 1980).

29. John Ruskin, *Modern Painters* (New York: John Wiley & Sons, 1885), Preface to the 2nd Edition, p. xvii.

30. John Ruskin, *Modern Painters*, vol. I, First American ed. from 3rd London ed. (New York: Wiley and Halsted, 1856–57), p. 44.

31. Asher B. Durand, "Letters on Landscape Painting," *The Crayon*, vol. I (1855), pp. 34–35, 97–98; repr., McCoubrey, p. 110.

32. The Pre-Raphaelite Brotherhood formed in England in 1848. The artist members of the group painted meticulously detailed landscapes, praised, at first, by Ruskin for their accurate recording of nature but later criticized by him for their use of artificial colors. The American Pre-Raphaelites or the Association for the Advancement of Truth in Art, to whom Prentice shows some stylistic affinity, were organized by Thomas Charles Farrer in 1863. The initial eight members, made up equally of artists, architects, geologists and lawyers, responded to a perceived need to reform American art and architecture. As Linda S. Ferber suggests in her essay, "'Determined Realists': The American Pre-Raphaelites and the Association for the Advancement of Truth in Art," "The proposed reform of American art was based upon principles of truth to nature and programs of study that were expounded by Ruskin and, in the opinion of the Association, demonstrated in the paintings of the English Pre-Raphaelite Brotherhood. . . ." Linda S. Ferber and William H. Gerdts, *The New Path: Ruskin and the American Pre-Raphaelites* (Brooklyn, N. Y.: The Brooklyn Museum, 1985), p. 11.

33. Richards' painting, a *Sea View*, was exhibited in the High School Building in Syracuse, in a show sponsored by the Social Art Club. *Syracuse Journal*, 7 March 1877. OHA, Syracuse. A seascape, *Off Gull Island, Fog Coming In*, was also shown in an exhibition sponsored by the Utica Art Association. Prentice could have seen the work of Jasper Cropsey, Albert Bierstadt, William Hart, David Johnson and A. F. Tait there as well. *The Daily Observer*, Utica, New York, 12 January 1878 and 5 February 1878. *The Syracuse Journal*, dated 5 February 1878, noted that Prentice traveled to Utica to "witness that exhibition." OHA, Syracuse.

34. The *Syracuse Journal* reported on 25 June 1877

that Prentice planned to spend "six or eight weeks among the Adirondacks this season" and would "enter the woods by way of Blue Mountain Lake early in July." The *Journal* again reported on 2 August 1877 that Prentice and two other artists (Cantwell and Gray) had left Syracuse "to take sketches among the Adirondacks." OHA, Syracuse. There is no record of either the landscape painter James Cantwell, or a Mr. Gray (first name unknown) being registered at Merwin's at the time Prentice stayed there. Cantwell was also well-known for his Adirondack landscapes.

35. Prentice may have visited Blue Mountain Lake on other occasions as well, but this is the only time that his name appears in the register. Blue Mountain House Registers, AML, Blue Mountain Lake.

36. George Frank Gates was active as a photographer in Syracuse between 1878 and 1881. His studio was located at 58 South Salina Street.

37. William K. Verner, unpublished iconographical analysis of the sepia photograph dated 20 February 1968. Adirondack Museum Artists' files, Blue Mountain Lake, hereafter cited as AMA, Blue Mountain Lake. Eagle Nest, located on Eagle Lake, a smaller lake situated between Blue Mountain and Utowana Lakes, was similar in name to a log cabin built on the site by the novelist Ned Buntline around 1860 called Eagle's Nest. Almost the exact view that Prentice recorded of Blue Mountain Lake from Merwin's can be seen as it appears today through the one-way viewing window in the Adirondack Museum.

38. Harold K. Hochschild, *An Adirondack Resort in the Nineteenth Century, Blue Mountain Lake, 1870–1900, Stagecoaches and Luxury Hotels* (Blue Mountain Lake, N.Y.: The Adirondack Museum, 1962).

39. According to the hotel registers, Prentice did not stay there, choosing Merwin's instead on his 1877 trip, perhaps because the rates were lower. The rate for room and board at Holland's was $10.00 a week as opposed to $7.00 at Merwin's.

40. The building was originally three stories and accommodated a maximum of thirty guests. The proprietor, Jim Ordway, charged $7.00–$15.00 per week for room and board. In 1879, Frederick C. Durant bought Prospect Point and the Ordway House, and, under his ownership and management, the hotel was enlarged and renamed the Prospect House, which he opened for business in 1882. Since the view of the lake and hotel recorded by Prentice depicts the original three-storied Ordway House, a much smaller structure and of different architectural style than the new Prospect House, the artist had to have at least sketched the scene prior to the beginning of construction on the new hotel. According to the present owners of the painting, Prentice is said to have stayed at the Ordway House in the 1880s, which means he may have continued to travel to the Adirondacks while he was living in Buffalo, New York, and after his last reported visit there in 1877.

41. John Boyd Thacher purchased the island shown from Jones Ordway and owned it from 1867–1945. The building located there was probably a private camp, perhaps Thacher's own. Harold K. Hochschild, *An Adirondack Resort in the Nineteenth Century*, pp. 9–11; 19–20.

42. Arthur Fitzwilliam Tait, who ventured into the Adirondacks as early as 1852, painted numerous Adirondack camping scenes. Their subsequent reproduction through chromolithographs published by Currier and Ives and Louis B. Prang brought the subject into the American home. William James Stillman's (1828–1901) painting *The Philosopher's Camp* of 1858 and Frederic Remington's (1861–1909) *Spring Trout Fishing in the Adirondacks—An Odious Comparison of Weights* of 1890 also documented the subject.

43. *Syracuse Journal*, 21 March 1877 and 25 June 1877. OHA, Syracuse.

44. George H. Perior was active in Syracuse during the 1870s. His photograph gallery was located at 64–66 South Salina Street, very near the studio of G. F. Gates. Smith's Lake (Lake Lila) located in the Nehasane Preserve in the northern part of Herkimer and Hamilton counties, was so named in 1895 by Dr. William Seward Webb in honor of his wife Lila Vanderbilt. Webb renamed Albany Lake, "Nehasane," which he also called the railroad station he had built on his property. Donaldson, *A History of the Adirondacks*, vol. I, p. 41.

45. OHA, Syracuse.

46. Two other Prentice paintings, *Landscape* (checklist no. 90) and *Sunrise on an Adirondack Lake* (plate 17) reveal his awareness of Tonalism.

47. A report published in the *Syracuse Journal* on 1 November 1873 (OHA, Syracuse) mentioned that Prentice had just returned from an extended five-week trip "among the Adirondacks." Albany Lake, now known as Nehasane Lake (see note 41) located

in the Nehasane Preserve, was referred to as one of the specific sites that the artist painted on that trip. Dr. Webb acquired the property while building the Adirondack and St. Lawrence Railroad in 1891–1892, and it was there that he built his Nehasane Lodge in 1893. For a discussion of Smith's Lake and Albany Lake prior to their name change, see E. R. Wallace, *Descriptive Guide to the Adirondacks and Handbook of Travel* (New York: The American News Company, 1875). There is no specific reference to a Towanda Camp on Smith's Lake or to a Watertown Camp on Albany Lake in this or subsequent editions of the *Guide*. William K. Verner has suggested that the Watertown camp property was quite logically named after a group of sportsmen from Watertown, New York, who may have owned it legally or by eminent domain, and whom Prentice might have accompanied on one of his painting excursions into the North Woods. William K. Verner, iconographical analysis of the sepia photograph of the painting dated 20 February 1968, AMA, Blue Mountain Lake. A sepia photograph by G. H. Perior also records the painting *Towanda Camp, Smith's Lake, Adirondacks, N.Y.* (checklist no. 75).

48. Prentice could actually have known A. F. Tait, as the latter lived year-round at Long Lake from 1874–1881, almost the same time frame that Prentice visited the area to paint. Prentice painted *Long Lake* (checklist no. 68) on his five-week fall trip that was reported in the *Syracuse Journal* on 1 November 1873. Tait moved to New York in 1881; Prentice was living in Brooklyn two years later. Warder H. Cadbury and Henry F. Marsh, *Arthur Fitzwilliam Tait: Artist in the Adirondacks* (Newark, Del.: The American Art Journal/University of Delaware Press, 1986). William K. Verner, after visiting the artist's daughter, Imogene, in Philadelphia in 1968, indicated that Prentice was definitely aware of Tait since there were copies of Tait's paintings by Prentice, including Tait's signature, hanging in the house. Imogene substantiated that information, saying that her father copied some of Tait's pictures. Prentice's painting, *Barnyard Scene* (plate 60), of a mother hen and her eight baby chicks, is strikingly similar to Tait's numerous depictions of the subject. The site recorded in *After the Hunt* could be from Constable's Point on Raquette Lake as well. AMA, Blue Mountain Lake.

49. Because of its irregular shape and many bays and promontories, the lake resembles a snowshoe. The lake is six miles long and almost as wide in certain spots. Also, as Donaldson suggested, the name could have been derived from the river known to the Saranac Indians as "the sounding river." Donaldson, *A History of the Adirondacks*, vol. I, p. 42.

50. Donaldson, *A History of the Adirondacks*, vol. II, p. 88.

51. The reporter noted that the painting was purchased by Harry Gray "who pronounces it as natural as life." *Syracuse Courier*, 25 March 1878. OHA, Syracuse. A sepia photograph, entitled *Raquette Lake from Wood's Clearing, Adirondacks, N.Y.*, taken by G. H. Perior, reproduces plate 13 and corroborates the location of the site depicted. Another painting entitled *At the Water's Edge* (checklist no. 15) includes a similar duck formation on the lake and is likely the same locale. Also, E. R. Wallace in his *Guide* of 1876 proclaimed "Wood's Lake great for wild ducks," but he does not refer to Raquette Lake specifically with that mention.

52. The *Syracuse Journal* reported on November 1, 1873, that Prentice visited Smith's Lake that fall and he may well have visited the same sites again on his return trip in 1877. The Shelburne Museum painting is not dated, but it could have been painted shortly after the artist's 1873 visit. On the other hand, the Adirondack Museum painting, dated 1883, was not executed until ten years later. This painting is another good example of Prentice returning to his portfolio of oil sketches or paintings from an earlier time period, perhaps for a commission or potential patron.

53. The actual site, as it can be seen today after a gradual climb of about one-half mile, is not spacious but is sufficient enough not to be frightening to a potential hiker.

54. Wallace indicated in his *Guide* that Prentice "re-discovered" Prentice Falls on one of his visits to the wooded area just below Merwin's. Wallace, *Guide to the Adirondacks*, 1888, p. 191. AML, Blue Mountain Lake.

55. Syracuse newspapers. OHA, Syracuse.

56. On March 31, 1875, the *Syracuse Journal* reported that "A fine painting by Prentice representing the 'St. Lawrence River and the Thousand Islands' is on exhibition at No. 16–18 North Salina Street [in the window of William A. Arnold, Clothier]. We understand the painting is for sale." We know that the artist traveled to the Thousand Islands on at least two occasions in 1875, as noted in the Syracuse newspaper report above and again on July 23, 1875.

In the latter, the reporter wrote, "L. W. Prentice, the artist, of this city, has been for several weeks at the Thousand Island House, Alexandria Bay. He is painting a large picture, five and one-half feet by three, of that splendid hostelry for the proprietors, Messrs. Staples and Nott." OHA, Syracuse. While that particular painting (checklist no. 137) has not been located, an engraving of the hotel, reproduced in Wallace's *Guide*, reveals what the hotel looked like in 1880. What could perhaps be the mansard roof of the central tower and one of the corner turrets of the hotel illustrated in the engraving are just barely visible over the trees in the painting *Launch on the Lake*. The outbuildings and the gazebo in Prentice's picture also bear a striking resemblance to those illustrated. It is conceivable that the engraving was made after the missing painting by Prentice.

57. On 21 March 1877, the *Syracuse Journal* reported that Prentice would receive a limited number of pupils in sketching and painting. That article also mentioned that he had commissions for several Adirondack paintings of specific locales. According to the same report, Prentice also continued to paint portraits, as the report noted "his portraits being commended as well as his landscapes." And again, on June 25, the same newspaper reported that Prentice would make many sketches for oil paintings and "will receive commissions from anybody who desires to have a particular locality represented by his pencil." OHA, Syracuse.

58. *Everson Museum of Art Bulletin*, April 1980. Everson Museum Artists' Files, Syracuse, New York.

59. *Syracuse Journal*, 2 December 1873. OHA, Syracuse. The most frequently depicted river is the Chenango River from which the Chenango Creek branches, near Sherburne, New York.

60. The Utica Central Railroad made the town easily accessible, and the Spring House and Sherburne House accommodated the many visitors to the area. Information provided by Mrs. Neva Conley, Town Historian, Sherburne, New York.

61. *Syracuse Journal*, 26 November 1873 and 2 December 1873. OHA, Syracuse. The painting was given two different titles in the reviews; in the former it was reported as *Sunday in the Afternoon* and in the latter, *Sunday Afternoon*. The idea that *South of Sherburne on the Chenango* was a second version (or replica) of *Sunday in the Afternoon* is supported by yet another mention of the latter painting appearing in the *Jour-*

nal on 12 January 1874. In that account, which reported the painting's sale to the President of the Utica and Black River Railroad, the reviewer stated that Prentice "will complete another painting of the same size and class but of different design which was commenced about a year since." The dimensions of *South of Sherburne on the Chenango* are identical to *Sunday in the Afternoon* (if we assume the smaller of the two dimensions to be accurate) and the 1875 date indicates its completion not long after being reported. *Sunday in the Afternoon* was also placed on display in the window of Kent and Miller's store on South Salina Street. The 2 December 1873, review concluded, "The gallery will richly repay the lovers of art for a visit to it, and their criticisms are invited by Mr. Prentice."

62. Conversation with Holman J. Swinney, Rochester, New York, July, 1991. A fourth painting which has recently come to light, though untitled, depicts the same area in the Chenango River valley that Prentice portrayed in the works discussed above (checklist no. 88).

63. At least Samuel W. was listed, but one assumes that Rhoda moved there with her husband. Buffalo and Erie County Historical Society, Buffalo, New York, and Erie County Hall, Buffalo, New York.

64. C. J. F. Binney, *History and Geneology of the Prentice Family* 2nd ed. (Boston: C. J. F. Binney, 1883), p. 34.

65. Real estate records. OHA, Syracuse. Prentice's father worked in Buffalo as a machinist, cabinetmaker and an art dealer; his brother Albert Duane was listed in the city directory as a confectioner, his younger brother Franklin Kent as a builder.

66. Susan Krane, *The Wayward Muse: A Historical Survey of Paintings in Buffalo* (Buffalo, N.Y.: Buffalo Fine Arts Academy, 1987). Gerdts, *Art Across America*, pp. 204–223. Information regarding Prentice and the Fine Arts Academy provided by Ms. Janice Lurie, Assistant Librarian, Albright-Knox Art Gallery, Buffalo, New York.

67. The checklist of the exhibition of 120 paintings, held May 9–20, 1882, in the Decorative Arts rooms of the Syracuse Savings Bank building, reveals that Prentice, (incorrectly spelled Prentiss) was represented by two landscapes listed as no. 2, *Landscape* (owned by Mrs. Bruce) and no. 35, *Raquette Lake* (price $150.00). OHA Syracuse.

68. Levi Wells Prentice's name appears in the Brooklyn Directory for the first time in the 1883/1884 volume.

69. Franklin's name first appears in the 1889/1890 Brooklyn Directory and Albert's name is listed for the first time in the Manhattan directory of that year. The artist's father, Samuel Wells Prentice, would die in Buffalo in 1884, the year after Prentice left the city. His mother, Rhoda, also moved east because she died in Medford, Long Island, around 1920, but it is not known whether she moved immediately after her husband's death or years later.

70. The Brooklyn Art Association opened with its inaugural exhibition in January 1861 and sponsored art exhibitions for nearly three decades. In 1891, the Association, the Student Art Guild of the Brooklyn Art Association, and the Department of Painting of the Brooklyn Institute of Arts and Sciences combined forces. The Brooklyn Art School resulted from that consolidation. The Brooklyn Art Association held its final exhibition in 1892. Clark S. Marlor, Ed.D, *History of the Brooklyn Art Association, with an Index of Exhibitions* (New York: James F. Carr, 1970), pp. 9, 45, 53, 59.

71. The exhibition was held March 21–23, 1887. From April 16–28, 1887, 196 paintings from the George F. Seney collection were shown at the Brooklyn Art Association, making the work of such American and European artists as George Inness, Alexander Wyant, Charles Francois Daubigny, and Jean Baptiste Camille Corot accessible to Prentice and others. Marlor, op. cit. p. 55. Thomas B. Clarke, a prominent collector of American art living in New York, also frequently lent his collection, which included Alexander Wyant, Winslow Homer, George Inness, Homer Martin, John Haberle, and Joseph Decker, for regular exhibitions at the National Academy of Design, the Metropolitan Museum of Art, the Brooklyn Union League, and the American Art Association, among others. The MMA exhibitions were held between 1880 and 1883; the Brooklyn Union League between 1884 and 1898. H. Barbara Weinberg, "Thomas B. Clarke: Foremost Patron of American Art from 1872–1899," *American Art Journal* (May 1976): 52–83.

72. Conversation with Dr. Clark S. Marlor regarding the Brooklyn Art Association, October 11, 1991.

73. According to his daughter Imogene and other relatives' recollections in letters contained in the AMA, Blue Mountain Lake.

74. The Brooklyn Museum Library, Catalogues of the Brooklyn Art Association.

75. Gerdts, *Art Across America*, vol. I, p. 140.

76. Prentice does not appear to have been a "joiner" throughout his artistic career in Brooklyn. He may have submitted work to both organizations and been rejected by the juries who made the selections for those exhibitions.

77. William H. Gerdts, *Painters of the Humble Truth: Masterpieces of American Still Life, 1801–1939* (Columbia, Mo.: Philbrook Art Center with University of Missouri Press, 1981), p. 102.

78. In the late 1880s and early 1890s, Decker's work underwent a major stylistic change. From creating hard, linear, complex compositions of fruit growing in the landscape, he turned to a more impressionistic style of softer, simplified forms arranged on a tabletop. His colors became less intense, his compositions less crowded. Contemporary reviews of Decker's work were quite harsh and may have caused him to alter his approach; however, it is even more likely that he followed the tonalist style of George Inness, whom he greatly admired. Decker knew George Inness personally, and it was after he painted Inness's portrait in 1883 that he changed his style. William H. Gerdts, *Joseph Decker (1853–1924): Landscapes and Images of Youth* (New York: Coe Kerr Gallery, 1988).

79. Someone attempted to pass off a Prentice *Still Life of Plums* with a forged Harnett signature in 1968, but it was discovered by Alfred V. Frankenstein, author of *After the Hunt: William Michael Harnett and other American Still Life Painters, 1820–1900* (Los Angeles: University of California Press, 1969) and its attribution as such was negated. Alfred Frankenstein to William K. Verner, AMA, Blue Mountain Lake.

80. Reproduced on numerous occasions and used as the cover illustration for William H. Gerdts' book on still life painting in America, *Painters of the Humble Truth*, the painting was previously thought to be Prentice's earliest still life composition. A still life of *Peaches* (checklist no. 197) dated 1884, however, predates it by eight years. The painting has also been reproduced in William H. Gerdts and Russell Burke, *American Still Life Painting* (New York: Praeger Publishers, 1971), p. 164, and Gerdts, *Art Across America*, p. 143. It has been included in such exhibitions

as "Painters of the Humble Truth" (Columbia, Missouri: Philbrook Art Center, 1981); "Nature's Bounty and Man's Delight" (New Jersey: The Newark Museum, June 15–September 28, 1958); "Masterpiece Paintings from the Museum of Fine Arts, Boston" (Boston: Museum of Fine Arts, 1986); "The American Painting Collection of Mrs. Norman B. Woolworth" (New York: Coe Kerr Gallery, Nov. 10–Nov. 28, 1978); "150 Years of American Still Life Painting" (New York: Coe Kerr Gallery, April 27–May 16, 1970); "American Still Life Paintings from the Paul Magriel Collection" (Washington, D.C.: Corcoran Gallery, Oct. 2–Nov. 10, 1957).

81. Gerdts and Burke, *American Still Life Painting*, p. 162.

82. Alberta Prentice Poppe, 1971, 1978, 1987, 1992 and the artist's grandnephew, Albert Prentice, 1965, to the Adirondack Museum, AMA, Blue Mountain Lake.

83. Imogene carried on this tradition of her father's, very often giving his paintings away as payment for services rendered to plumbers, contractors, etc. in the Germantown area. From conversations with her friend and neighbor, Anne Van Gobes and her recollections to William K. Verner. AMA, Blue Mountain Lake.

84. *Syracuse Journal*, 19 March 1895. OHA, Syracuse. Cantwell refers to the Onondaga Valley.

85. Levy [*sic*] W. and Levi W. were listed as "artist" at two different addresses in that and subsequent volumes until 1920. Beginning in the 1909 volume, the artist's son, Leigh Wells, is also listed at the same address as his father. After 1920, neither Prentice is listed in the directory until Leigh's name appears again in the 1926 volume along with his sister, Imogene, both living at 5006 N. Erringer Place. The children continued to be listed yearly thereafter. No listing appears for their father again until 1935, the year he died. No occupation for him is listed that year, and his address reveals he was living with his two children. Prentice's wife, Emma, also appears in the directory at the same address as her children beginning in 1930. Real estate records indicate Leigh purchased the house at 5006 N. Erringer Place in 1925. *Boyd's Street and Avenue Directory of the City of Philadelphia* (Philadelphia, Pa.: C.E. Howe Company, 1903–1935).

86. Both his daughter, Imogene, and his grandniece, Alberta, verified the existence of cataracts, although only Imogene indicated that her father continued painting afterward. Cataracts cloud the lens of the eye and can progress either slowly or rapidly, depending on the type, and the individual becomes more and more nearsighted. Prentice could have continued to paint his tabletop still lifes with the same sharp focus if he situated them close enough to his easel. After surgery, which was considered major in 1923, Prentice would have worn thick corrective glasses to see. It is likely that the significant decrease in the artist's output was a result of his failing eyesight. I am indebted to William Tasman, M.D., Philadelphia, for his assistance with the above information.

87. Very little else is known of the artist's life in Philadelphia and Connecticut. According to its records, Prentice was not a member nor did he exhibit with the Pennsylvania Academy of Fine Art, and his artistic activities were not followed by the newspapers during his years in either location. Several family members suggested that Prentice effectively abandoned his family in Philadelphia in favor of his studio in Connecticut and that his wife supported the two children in Germantown by giving piano lessons and teaching Sunday School at the Baptist Church there. AMA, Blue Mountain Lake. According to his relatives, Prentice also reconstructed the windows for the Sacred Heart Church (now destroyed) in Bridgeport.

88. Alberta Prentice Poppe to the Adirondack Museum. AMA, Blue Mountain Lake.

89. Conversation with Mrs. Anne Van Gobes, Philadelphia, 1990.

90. Prentice could have easily made a trip from Philadelphia to paint the Pine Barrens in New Jersey.

91. "Death Claims Levi W. Prentice," *Philadelphia Journal of Commerce*, vol. LX, no. 10, Saturday, 7 December 1935, p. 9. A second obituary was published in *The Philadelphia Inquirer*, Sunday Morning, 1 December 1935, sec. 2, p. 2 and a third in the *New York Times*, Sunday, 1 December 1935, sec. 2, p. 10.

92. Prentice had moved away from New York City ten years prior to the Armory Show to a more insulated, academic environment in Philadelphia where the European and early American modernists may not have had the same impact.

93. "Death Claims Levi W. Prentice," *Philadelphia Journal of Commerce*, op. cit.

Selected Bibliography

"America in the Stereoscope." *The Art Journal* VI, No. 7 (July 1860): 221.

Binney, C.J.F. *History and Geneology of the Prentice Family.* 2nd ed. Boston: C.J.F. Binney, 1883.

Brewer, Donald J. "Reality and Deception." *American Art Review* (January–February 1975): 79–91.

Burke, Russell, and Gerdts, William H. *American Still Life Painting.* New York: Praeger, 1971.

Cadbury, Warder H., and Marsh, Henry F. *Arthur Fitzwilliam Tait: Artist in the Adirondacks.* Newark, Del.: The American Art Journal/University of Delaware Press, 1986.

Cooper, Helen A. "The Rediscovery of Joseph Decker." *The American Art Journal* (May 1978): 55–71.

Cunningham, Linda. "Five Painters Practicing in the Syracuse Area during the latter Nineteenth Century." Research Paper, Onondaga Historical Association, Syracuse, N.Y., 1961.

Darrah, William Culp. *Stereoviews: A History of Stereographs in America and their Collection.* Gettysburg, Pa.: Times & News Publishing Co., 1964.

Donaldson, Alfred L. *A History of the Adirondacks.* 2 vols. Harrison, N.Y.: Harbor Hill Books, 1977.

Earle, Edward W. *Points of View: The Stereograph in America—A Cultural History.* New York: The Visual Studies Workshop Press, in collaboration with The Gallery Association of New York State, 1979.

Ferber, Linda S., and Gerdts, William H. *The New Path: Ruskin and the American Pre-Raphaelites.* Brooklyn, N.Y.: The Brooklyn Museum, 1985.

Frankenstein, Alfred. *After the Hunt: William Michael Harnett and other American Still Life Painters, 1820–1900.* Los Angeles: University of California Press, 1969.

———. "J. F. Francis." *Antiques Magazine,* (May 1951): 374–377.

Gerdts, William H. *Art Across America: Two Centuries of Regional Painting 1710–1920.* New York: Abbeville Press, 1990.

———. *Painters of the Humble Truth. Masterpieces of American Still Life, 1801–1939.* Columbia, Mo.: Philbrook Art Center with University of Missouri Press, 1981.

Hochschild, Harold K. *An Adirondack Resort in the Nineteenth Century, Blue Mountain Lake, 1870–1900, Stagecoaches and Luxury Hotels.* Blue Mountain Lake, N.Y.: The Adirondack Museum, 1962.

———. *Life and Leisure in the Adirondack Backwoods.* Blue Mountain Lake, N.Y.: The Adirondack Museum, 1962.

Howat, John K. *American Paradise: The World of the Hudson River School.* New York: The Metropolitan Museum of Art, 1987.

Krane, Susan. *The Wayward Muse: A Historical Survey of Painting in Buffalo.* Buffalo, N.Y.: Buffalo Fine Arts Academy, 1987.

Lindquist-Cock, Elizabeth. *The Influence of Photography on American Landscape Painting, 1839–1880.* New York: Garland, 1977.

Landow, George. *Aesthetic and Critical Theories of John Ruskin.* New Jersey: Princeton University Press, 1971.

Mandel, Patricia C. F. *Fair Wilderness: American Paintings in the Collection of the Adirondack Museum.* Blue Mountain Lake, N.Y.: The Adirondack Museum, 1990.

Marzio, Peter C. *The Democratic Art: Chromo-*

lithography 1840–1900. Boston: David R. Godine, 1979.

Marlor, Clark S., Ed.D. *History of the Brooklyn Art Association with an Index of Exhibitions.* New York: James F. Carr, 1970.

McClinton, Katharine Morrison. *The Chromolithographs of Louis Prang.* New York: Clarkson N. Potter, Inc., 1973.

McCoubrey, John W. *American Art 1700–1960 Sources and Documents.* Englewood Cliffs, N.J.: Prentice-Hall, Inc., 1965.

McShine, Kynaston. *The Natural Paradise: Painting in America 1800–1950.* New York: Museum of Modern Art, 1976.

Murray, William H. H. *Adventures in the Wilderness.* Blue Mountain Lake, N.Y.: The Adirondack Museum and Syracuse University Press, 1970.

Novak, Barbara. *American Painting of the Nineteenth Century.* New York: Harper & Row, 1979.

———. "Grand opera and the small still voice." *Art in America* (March–April 1971): 64–73.

———. *Nature and Culture: American Landscape Painting 1825–1875.* New York: Oxford University Press, 1980.

O'Brien, Margaret Goodwin. "Notes on Adirondack Artists." Unpublished manuscript, Adirondack Museum Library, Blue Mountain Lake, N.Y., n.d.

Owens, Gwendolyn. *Golden Day, Silver Night: Percpetions of Nature in American Art 1850–1910.* Cornell University, Ithaca, N.Y.: Herbert F. Johnson Museum of Art, 1982.

Staley, Allen. *The Pre-Raphaelite Landscape.* Oxford: Clarendon Press, 1973.

Stein, Roger B. *John Ruskin and Aesthetic Thought in America 1840–1900.* Cambridge, Mass.: Harvard University Press, 1967.

Sweeney, J. Gray. *Themes in American Painting.* Grand Rapids, Mich.: The Grand Rapids Art Museum, 1977.

Verner, William K. Intro. to *The Story of Adirondac* by Arthur H. Masten. Blue Mountain Lake, N.Y.: The Adirondack Museum and Syracuse University Press, 1968.

———. "Art and the Adirondacks." *Antiques Magazine* (July 1971): 84–92.

———. "The Adirondack Painters." *The Conservationist* (April–May, 1968): 10–11.

———. "The Decline of the Adirondack Painters." *The Conservationist* (April–May, 1969): 17, 40.

Wallace, Edwin R. *Descriptive Guide to the Adirondacks and Handbook of Travel.* New York: The American News Company, 1875–1880.

STILL LIFES

PLATE 33

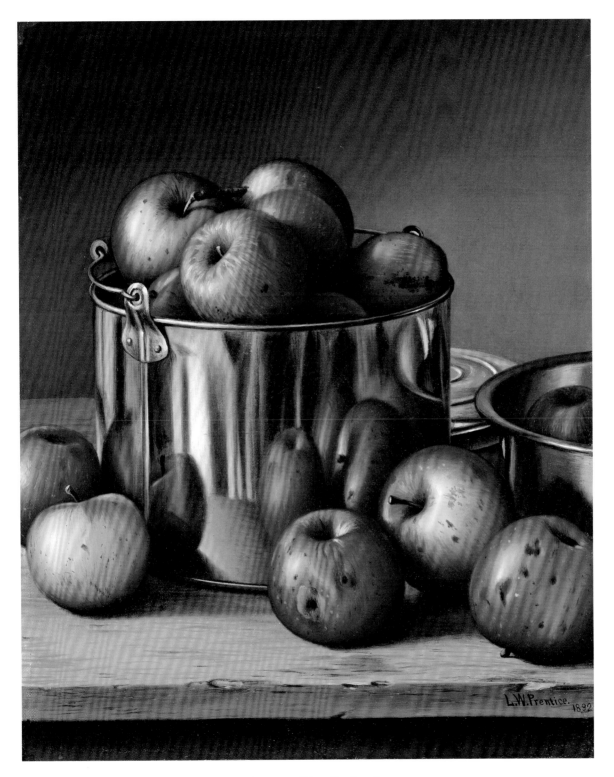

Apples in a Tin Pail 1892
Oil on canvas 16 x 13. Collection Museum of Fine Arts, Boston. The Hayden Fund.
Checklist no. 156.

PLATE 34

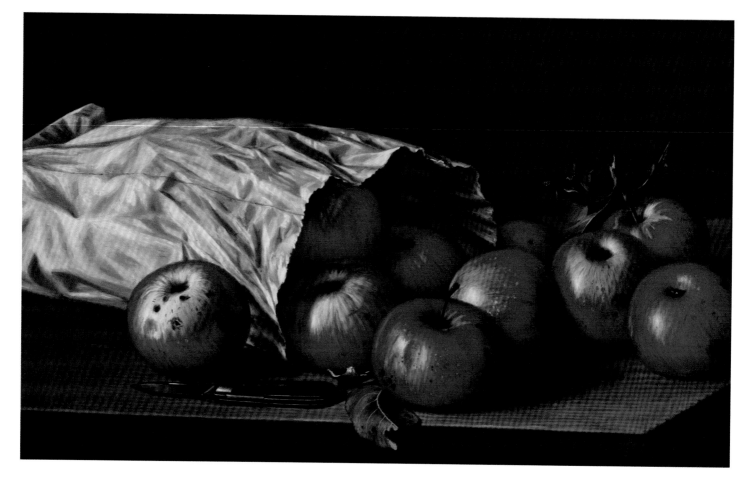

Bag of Apples 1894

Oil on canvas 11 x 18. Collection Louisiana Arts and Science Center. Checklist no. 159.

PLATE 35

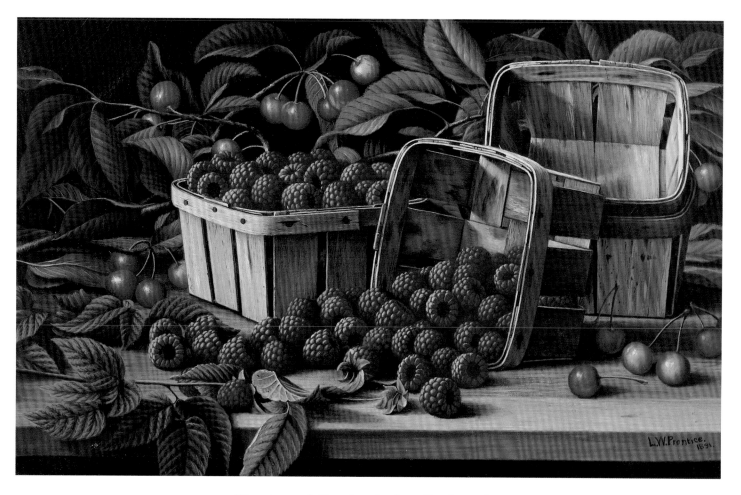

Cherries and Raspberries in a Basket 1891

Oil on canvas 12 x 19. Collection Hood Museum of Art, Dartmouth College, Hanover, N.H.

Checklist no. 175.

PLATE 36

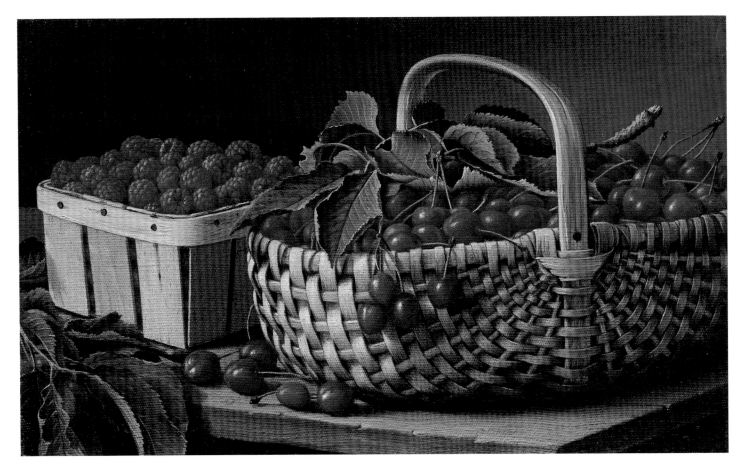

Still Life with Berries
Oil on canvas 9 x 15. Private Collection. Checklist no. 218.

PLATE 37

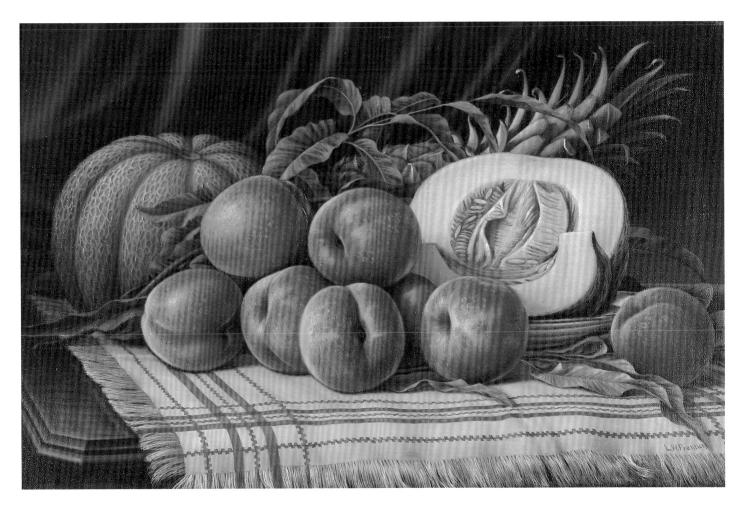

Melons, Peaches and Pineapple
Oil on canvas 12 x 19. Collection Walter and Ann Knestrick. Checklist no. 192.

PLATE 38

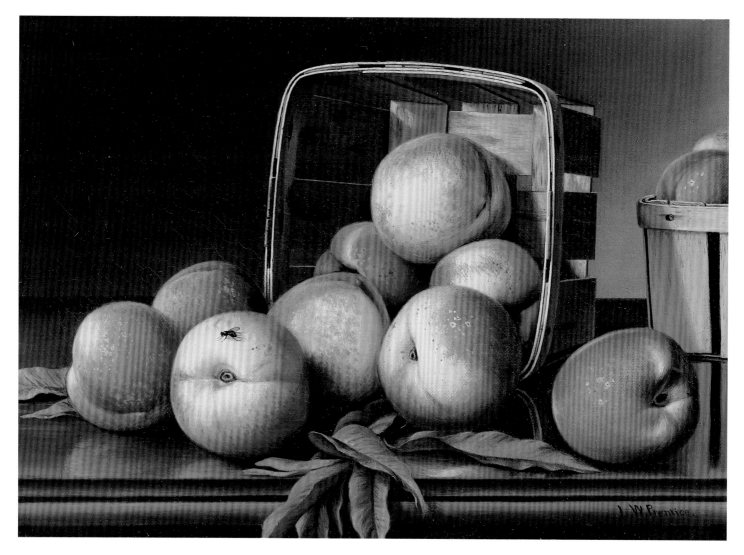

Peaches in a Basket

Oil on canvas 10 x 14. Collection Walter and Lucille Rubin. Checklist no. 201.

PLATE 39

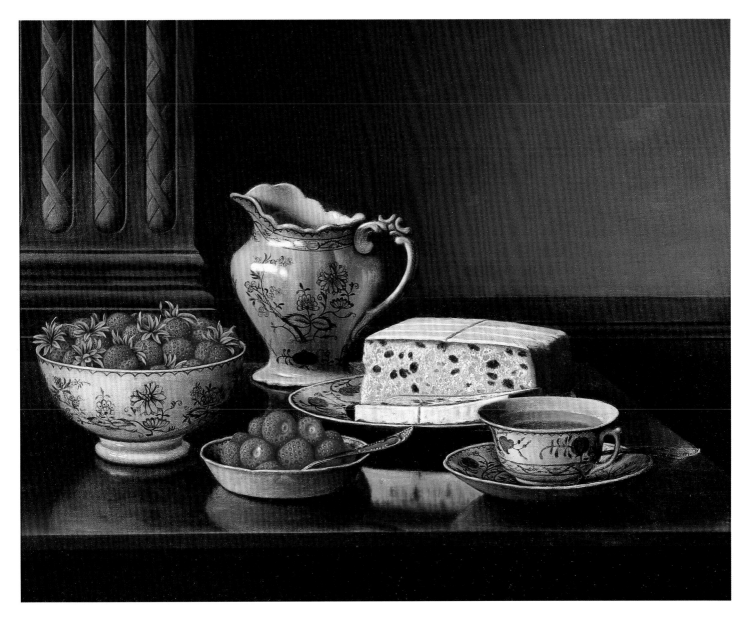

Still Life with Strawberries ca. 1890

Oil on canvas 16 x 20. Collection Carnegie Museum of Art, Pittsburgh. Checklist no. 230.

PLATE 40

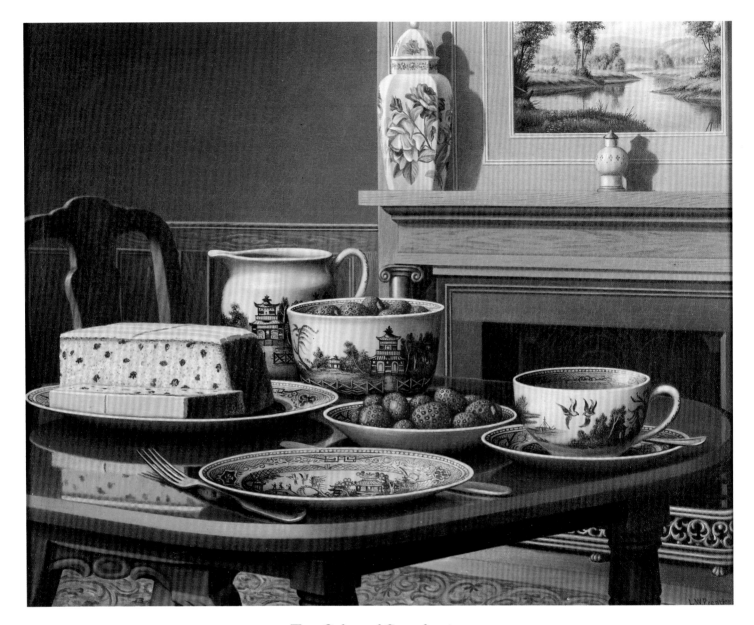

Tea, Cake and Strawberries

Oil on canvas 16 x 20. Private Collection. Photograph © 1991 Sotheby's, Inc.

Checklist no. 238.

PLATE 41

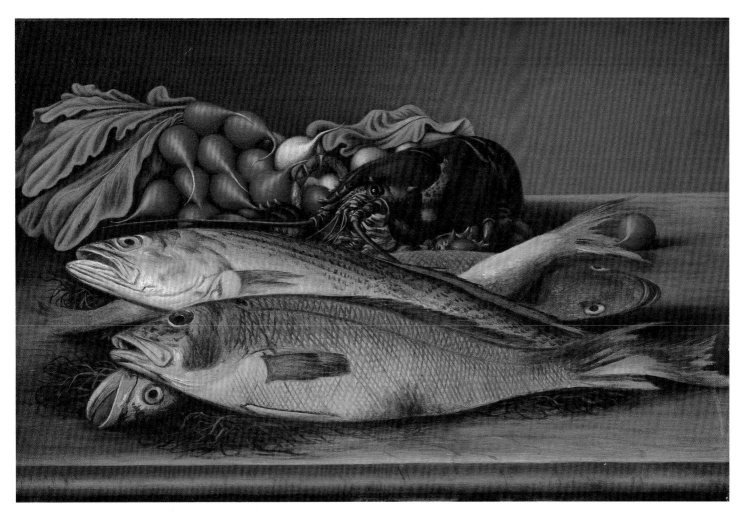

Fish, Lobster and Radishes
Oil on canvas 12 x 18. Private Collection. Checklist no. 179.

PLATE 42

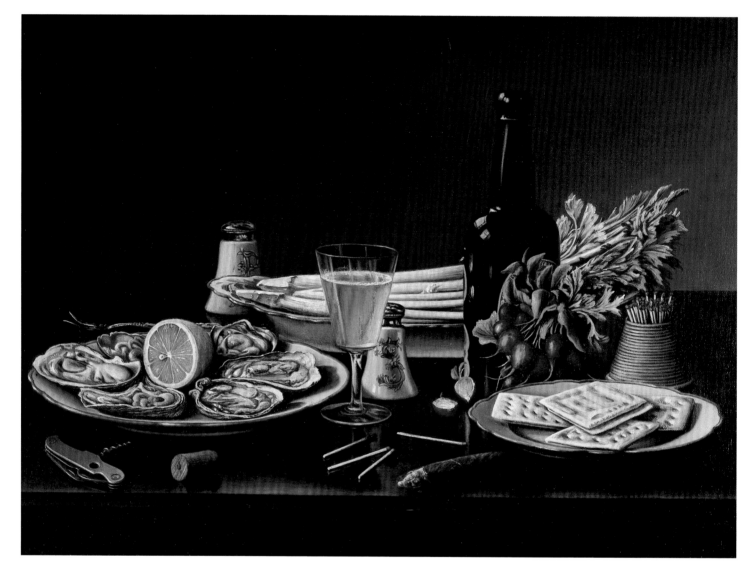

Still Life with Oysters ca. 1890

Oil on canvas 16 x 22. The Regis Collection. Checklist no. 223.

PLATE 43

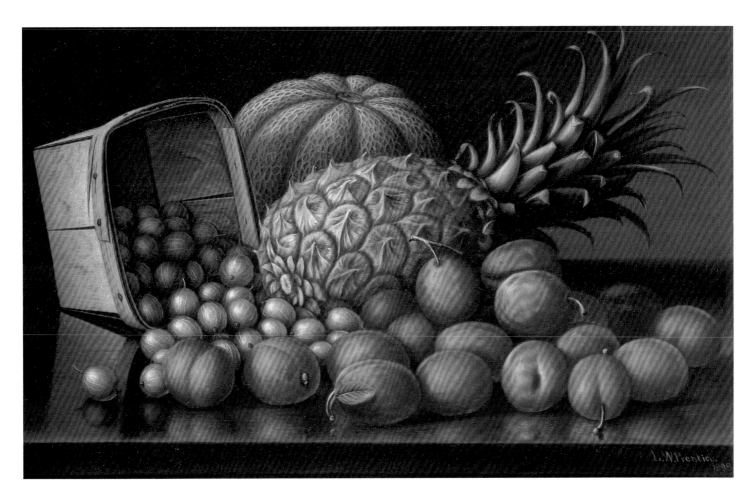

Gooseberries, Plums, Pineapple and Cantaloupe 1899

Oil on canvas 12 x 18. Private Collection. Checklist no. 183.

PLATE 44

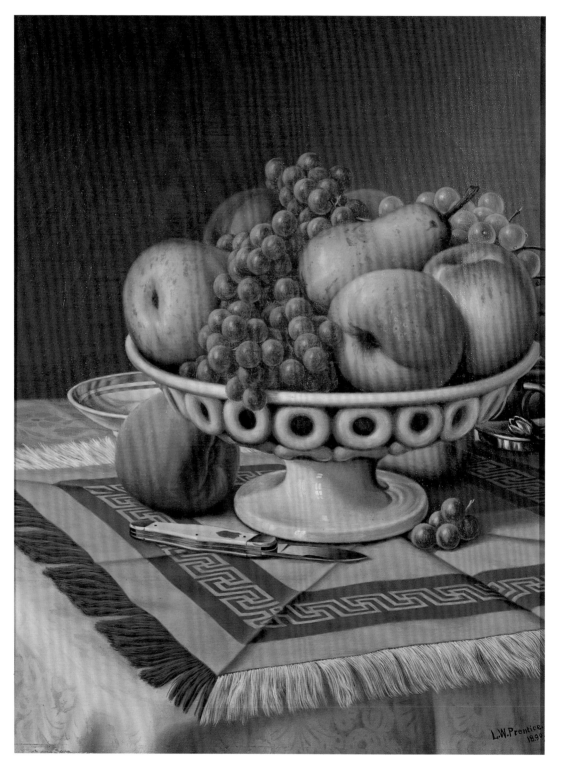

Still Life with Bowl of Fruit 1890

Oil on canvas 16 x 13. Collection Berry-Hill Galleries, New York. Checklist no. 219.

PLATE 45

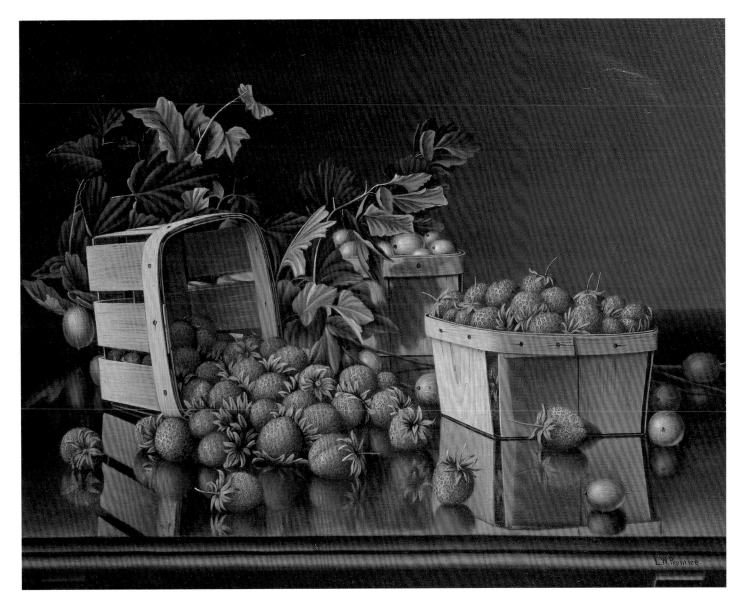

Baskets of Strawberries and Gooseberries on a Ledge
Oil on canvas 16 x 20. Private Collection. Checklist no. 167.

PLATE 46

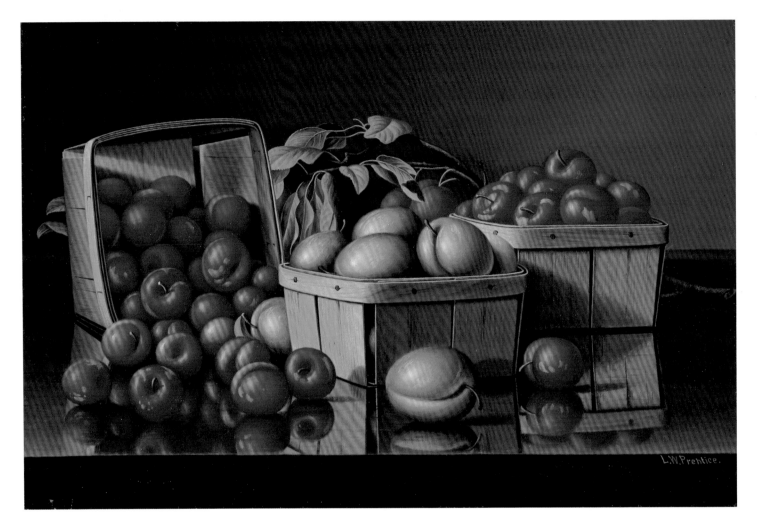

Still Life with Plums

Oil on canvas 12 x 18. Collection Detroit Institute of Arts, Founders Society Purchase,

Merrill Fund. Checklist no. 229.

PLATE 47

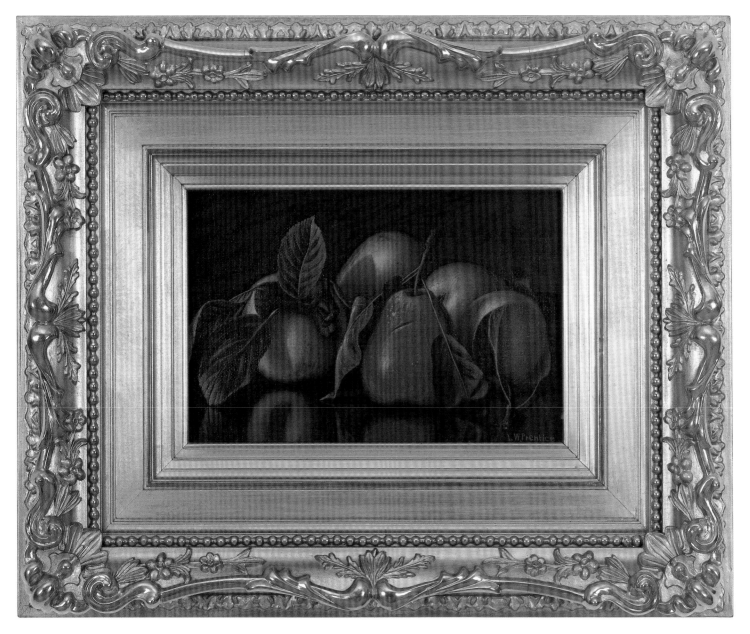

Still Life with Pears

Oil on canvas 6 x 9. Collection Sylvain and Anne Van Gobes. Checklist no. 225.

PLATE 48

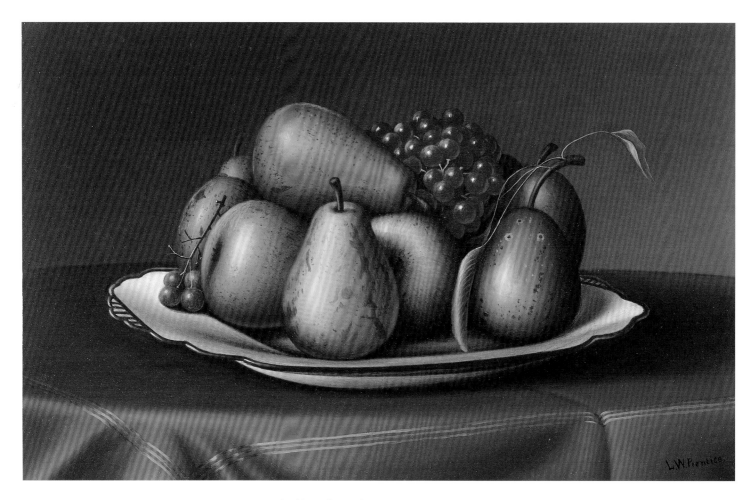

Still Life with Pears and Grapes
Oil on canvas 10 x 16. Private Collection. Checklist no. 226.

PLATE 49

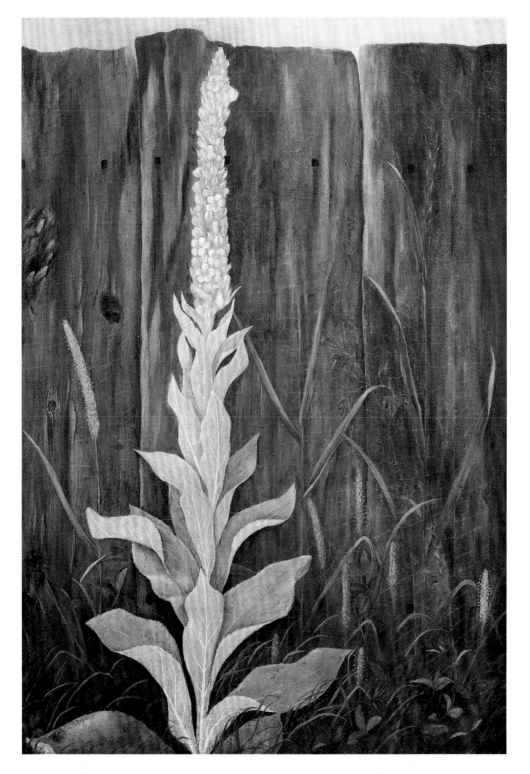

Flowering Plant against a Fence
Oil on canvas 26 x 18. Collection Berry-Hill Galleries, New York. Checklist no. 180.

PLATE 50

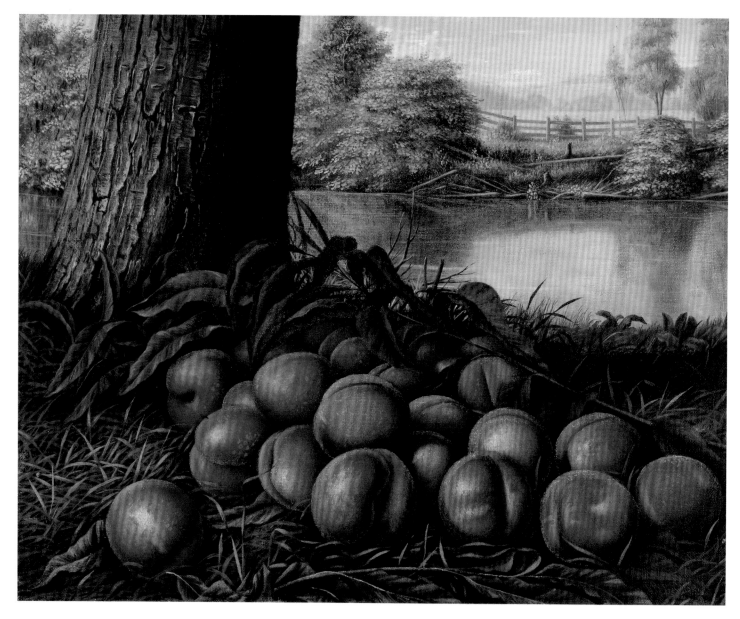

Peaches in a Landscape
Oil on canvas 16 x 20. Private Collection. Checklist no. 202.

PLATE 51

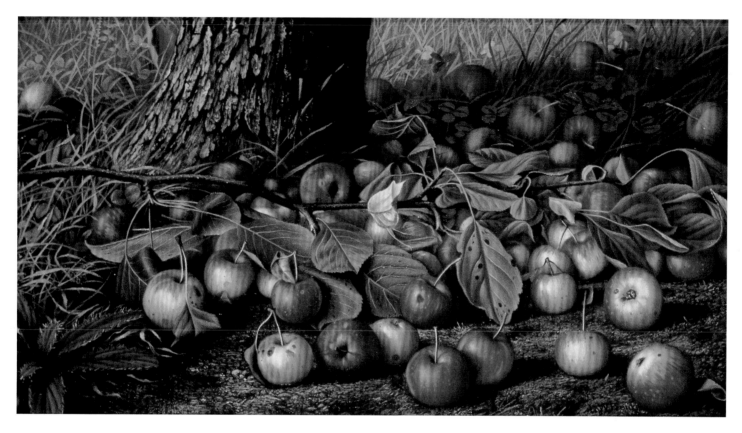

An Abundance of Apples
Oil on canvas 10 x 18. Collection The Montclair Art Museum. Checklist no. 140.

PLATE 52

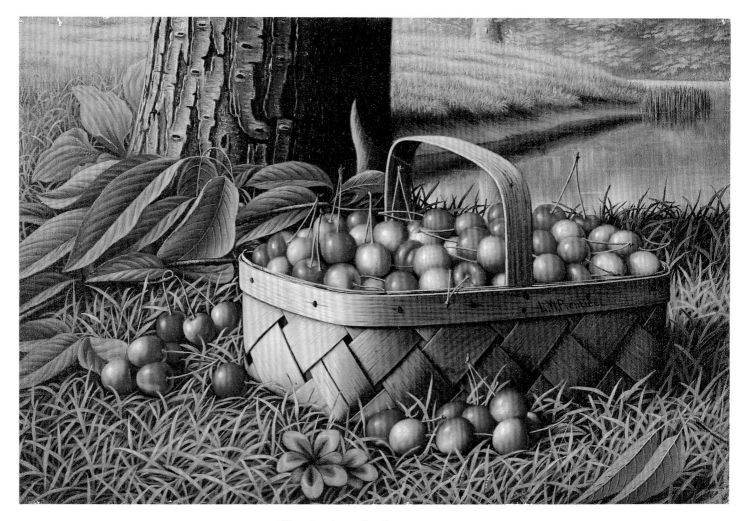

Cherries in a Basket ca. 1895

Oil on canvas 12 x 18. Collection Yale University Art Gallery, John Hill Morgan, B.A. 1893, Fund.

Checklist no. 176.

PLATE 53

Bushels of Apples under a Tree
Oil on canvas 24 x 20. Collection Eleanor M. Foster. Checklist no. 170.

PLATE 54

Apples in a Basket 1891
Oil on canvas 20 x 16. Collection Walter and Lucille Rubin. Checklist no. 149.

PLATE 55

Basket of Apples beneath a Tree
Oil on canvas 10 x 18. Collection Gilbert Butler. Photograph courtesy Gerold Wunderlich & Co., New York.
Checklist no. 164.

PLATE 56

Cherries on a Bough ca. 1895

Oil on canvas 9 x 15. Collection Joan B. Mirviss and Robert J. Levine. Checklist no. 177.

PLATE 57

Bed of Strawberries with Monarch Butterfly
Oil on canvas 12 x 16. Collection Edward and Vivian Merrin. Checklist no. 168.

PLATE 58

Raspberry Bush

Oil on canvas 7 x 15. Collection Rahr-West Art Museum. Checklist no. 207.

PLATE 59

Strawberries Spilling from a Basket and Growing on a Bush
Oil on canvas 12 x 10. Collection Mr. and Mrs. Howard J. Godel. Checklist no. 237.

PLATE 60

Barnyard Scene
Oil on canvas 12 x 18. Private Collection. Checklist no. 281.

PLATE 61

Pig-Pen
Oil on canvas 12 x 18. Collection Susan Ellis Stebbins. Checklist no. 284.

PLATE 62

A Portrait
Oil on canvas 24 x 20. Collection Yale University Art Gallery,
Joseph D. Schwerin, B.A. 1960, Fund. Checklist no. 285.

PLATE 63

Tibby [Imogene's cat]

Oil on canvas 13 x 19. Collection Sylvain and Anne Van Gobes. Checklist no. 286.

PLATE 64

Afternoon Idyll 1920
Oil on canvas 15 x 20. Collection Anderson & Co. Fine Arts, Grosse Point Farms, Michigan.
Checklist no. 278.

Checklist of Paintings

KEY TO CHECKLIST

All dimensions are in inches, height x width. The Checklist is arranged by category, and paintings are listed alphabetically by title within each category. Title, date, medium, dimensions, signature and collection or institution are given for each painting when known.

Paintings that have not been located are listed separately within categories. If information is missing, it is not known. The numbers of paintings in the exhibit and illustrated in color in the catalogue are indicated by an asterisk [].*

ADIRONDACK LANDSCAPES

1. *Adirondack Camp near Blue Mountain Lake*
 Oil on canvas 12 x 18
 Signed l.r.
 Private Collection

2. *Adirondack Farm*, 1883
 Oil on canvas 13 x 24
 Signed and dated l.r.
 Collection: New York State Museum,
 Albany, N.Y.

3. *An Adirondack Lake*, 1876
 Oil on canvas 36 x 66
 Signed and dated l.r.
 Collection: Gerold Wunderlich & Co.,
 New York, N.Y.

4. *Adirondack Lake View*
 Oil on canvas 19 x 12
 Signed in pcl. on stretcher
 Collection: Rodger Sweetland

5. *Adirondack Lake View*
 Oil on canvas 19 x 12
 Signed in pcl. on stretcher
 Collection: Rodger Sweetland

6. *Adirondack Landscape*
 Oil on canvas 4 x 11
 Signed l.r.
 Collection: Herschel and Fern Cohen

7. *Adirondack Landscape*
 Oil on canvas dimensions unknown
 Unknown
 Collection: Raydon Gallery,
 New York, N.Y.

8. *Adirondack Landscape*
 Oil on canvas 20 x 16
 Signed l.r.
 Private Collection

9. *Adirondack Landscape*
 Oil on canvas 10 x 18
 Signed l.r.
 Private Collection

*10. *Adirondack Scene*
 Oil on canvas 35 x 44
 Signed l.r.
 Collection: Onondaga Historical
 Association, Syracuse, N.Y.

*11. *Adirondack Scene*
 Oil on panel 10 x 5
 Signed l.r.
 Collection: Herschel and Fern Cohen

12. *Adirondack View*
 Oil on panel 5 x 9
 Signed l.r.
 Collection: Albert Roberts

13. *Adirondacks*, 1873
Oil on canvas 18 x 32
Signed and dated l.r.
Collection: Arthur E. Imperatore

*14. *After the Hunt*, 1879
Oil on canvas 17 x 31
Signed and dated l.r.
Collection: William B. Ruger

15. *At the Water's Edge*, 1881
Oil on canvas 26 x 48
Signed and dated l.r.
Private Collection

*16. *Big Tupper Lake, Mt. Morris in the Distance*
Oil on canvas 4 x 11
Signed l.r.
Collection: Albert Roberts

17. *Birch Trees*
Oil on canvas 12 x 9
Signed l.l.
Collection: William B. Ruger

18. *Blue Mountain Lake*
Oil on canvas 15 x 26
Signed l.r.
Collection: Bob and Tina Veder

*19. *Blue Mountain Lake, Adirondacks*, 1874
Oil on canvas 30 x 54
Signed and dated l.r.
Collection: Richard J. Fay

*20. *Blue Mountain Lake with Ordway House*,
ca. 1878
Oil on canvas 15 x 24
Signed l.r.
Collection: Donald and Ann Jones

*21. *Camping by the Shore*
Oil on canvas 12 x 18
Signed l.r.
Collection: Adirondack Museum,
Blue Mountain Lake, N.Y.

22. *Early Fall on Smith's Lake, in the
Adirondacks*
Oil on canvas 10 x 18
Signed l.r.

Collection: David R. Godine, Publisher,
Boston, Mass.

23. *Deer in an Adirondack Lake*
Oil on canvas 12 x 10
Signed l.r.
Collection: Walter and Lucille Rubin

24. *Gold and Silver Beach, Raquette Lake*
Oil on canvas 18 x 35
Not signed
Collection: Adirondack Museum,
Blue Mountain Lake, N.Y.

*25. *Lake Lila*
Oil on canvas 33 x 57
Signed l.r.
Collection: Mrs. John Davies Reed

26. *Lake Lila in the Adirondacks*
Oil on canvas 10 x 20
Signed l.l.
Collection: The Shelburne Museum,
Shelburne, Vt.
Gift of the Adirondack Museum

27. *Landscape*
Oil on canvas board 5 x 7
Unknown
Private Collection

*28. *Landscape* ["Mull Pond" written in
pcl. verso]
Oil on canvas 11 x 9
Signed in pcl. on stretcher
Collection: Charles F. Flanagan

29. *Landscape with Lake and Distant Mountain*
Oil on canvas 7 x 5
Signed l.r.
Collection: Phyllis and Paul Pransky

*30. *Moonlight Camping at Schroon Lake*, 1890
Oil on canvas 12 x 23
Signed and dated l.r.
Collection: Richard J. Fay

*31. *Moose River, Adirondacks*, 1884
Oil on canvas 30 x 22
Signed and dated l.l.
Collection: Richard J. Fay

32. *Night Scene, Smith's Lake*
Oil on canvas 12 x 23
Signed on selvage edge
Collection: Adirondack Museum,
Blue Mountain Lake, N.Y.
Gift of Harold K. Hochschild

33. *On the Saranac*
Oil on canvas 18 x 32
Signed l.r.
Collection: Gilbert Butler

*34. *Rac [sic] Lake*
Oil on canvas 4 x 11
Signed l.r.
Collection: Albert Roberts

35. *Raquette Lake*, 1883
Oil on canvas 18 x 29
Signed and dated l.r.
Collection: William B. Ruger

*36. *Raquette Lake*
Oil on canvas 11 x 19
Signed l.r.
Collection: Adirondack Museum,
Blue Mountain Lake, N.Y.
Gift of Huntington Memorial Camp
(Camp Pine Knot).

*37. *Raquette Lake*
Oil on canvas 18 x 35
Signed l.r.
Collection: John C. Wunderlich

*38. *Raquette Lake from Wood's Clearing,
Adirondacks, N.Y.*, 1877
Oil on canvas 26 x 50
Signed and dated l.r.
Collection: Gilbert Butler

39. *Raquette Lake, The Adirondacks*, 1894
Oil on canvas 24 x 48
Not signed
Private Collection

*40. *Raquette Lake—The Start of Autumn*, 1889
Oil on canvas 13 x 28
Signed and dated l.r. and verso
Collection: Walter and Lucille Rubin

41. *Reflections in the Pond*
Oil on canvas 24 x 20
Signed l.l.
Private Collection

*42. *River Valley Landscape*, 1871
Oil on canvas 36 x 60
Signed and dated l.l.
Private Collection

43. *Ruffed Grouse*, 1883
Oil on academy board 13 x 11
Signed and dated l.r.
Collection: Adirondack Museum,
Blue Mountain Lake, N.Y.

44. *Saranac Lake*
Oil on canvas 6 x 10
Signed l.r.
Collection: D. Wigmore Fine Art,
New York, N.Y.

*45. *Smith's Lake, Adirondacks, N.Y.*, 1883
Oil on canvas 26 x 48
Signed and dated l.r.
Collection: Adirondack Museum,
Blue Mountain Lake, N.Y.
Gift of Mr. and Mrs. Harold K.
Hochschild.

*46. *Sunrise on an Adirondack Lake*, 1883
Oil on canvas 9 x 15
Signed and dated l.r.
Collection: Richard J. Fay

47. *View in the Adirondacks*, 1873
Oil on canvas 42 x 72
Signed and dated l.r.
Collection: Albany Institute of History
and Art, Albany, N.Y.

48. *View in the Adirondacks*, 1873
Oil on canvas 26 x 44
Signed and dated l.r.
Collection: Adirondack Museum,
Blue Mountain Lake, N.Y.

49. *View in the Adirondacks*, 1886
Oil on canvas 9 x 15
Signed and dated l.r.
Collection: Charles R. Tucker

*50. *Watertown Camp, Albany Lake,*
Adirondacks, N.Y.
Oil on canvas 11 x 19
Signed l.r.
Collection: Lynn H. Boillot

*51. *White Birches of the Racquette* [*sic*]
Oil on canvas 30 x 25

Signed l.r.
Collection: Adirondack Museum,
Blue Mountain Lake, N.Y.
Gift of Mrs. Franklin Kent Prentice, Jr.,
in memory of Franklin Kent Prentice,
Jr., artist's nephew.

LOCATION UNKNOWN

52. *Adirondack Lake*
Oil on canvas 8 x 15
Signed l.r.

53. *Adirondack Landscape*
Oil on canvas

54. *Adirondack Landscape*
Oil on artist's board 6 x 12
Signed l.r.

55. *Adirondacks,* 1877
Oil on canvas 30 x 48

56. *Autumn Landscape*
Oil on canvas 7 x 5
Signed l.r.

57. *Autumn Landscape with Deer*
Oil on panel 6 x 12
Signed l.r.

58. *Autumn Overlook, the Adirondacks*
Oil on canvas 7 x 5
Signed l.r.

59. *Blue Lake, Adirondacks,* 1889
Oil on canvas 13 x 28
Signed and dated verso

60. *Blue Mountain House, Adirondacks*
Oil on canvas

61. *Blue Mountain Lake, Adirondacks*
Oil on canvas

62. *Blue Mountain Lake, Adirondacks from
Merwin's*
Oil on canvas

63. *Forked Lake*
Oil on canvas

64. *Head of Big Tupper Lake from
Coleman's Point*
Oil on canvas

65. *Lake George*
Oil on canvas 8 x 15
Signed verso

66. *Lake Placid*
Oil on canvas

67. *Little Tupper Lake*
Oil on canvas

68. *Long Lake*
Oil on canvas

69. *Mud Lake, Adirondacks*
Oil on canvas 22 x 35

70. *No. Four Lake in the Fulton Chain*
Oil on canvas

71. *Princess Falls* ["Prentice" Falls]
Oil on canvas

72. *Raquette Lake, Adirondacks*
Oil on canvas 26 x 46

73. *Raquette Lake, toward Blue Mountain,
Adirondacks,* ca. 1880
Oil on canvas 18 x 32
Signed l.r.

74. *Round Lake from Ampersand Mountain*
Oil on canvas

75. *Towanda Camp, Smith's Lake, Adirondacks, N.Y.*, 1878
 Oil on canvas

76. *Upper Saranac Lake*
 Oil on canvas

77. *Wooded Landscape*
 Oil on canvas

OTHER LANDSCAPES

78. *Above Beardsley Park, Bridgeport, Connecticut*
 Oil on canvas 12 x 16
 Signed l.l. and titled verso
 Private Collection

79. *Boy and Dog in Front of House*
 Oil on canvas 20 x 14
 Signed l.r.
 Private Collection

*80. *Chenango Creek, Three Miles North of Sherburne, N.Y.*, 1877
 Oil on canvas 26 x 50
 Signed and dated l.r.
 Collection: H. J. Swinney

81. *Cows Watering in a Stream*
 Oil on canvas 10 x 8
 Signed l.r.
 Collection: Mark LaSalle Fine Art, Albany, N.Y.

*82. *The Gorge at Letchworth Park*
 Oil on canvas 14 x 22
 Signed l.r.
 Collection: Naomi's Art, Inc., New York, N.Y.

*83. *Hopper's Gorge, Onondaga Valley*
 Oil on canvas 30 x 22
 Signed l.r.
 Collection: Everson Museum of Art, Syracuse, N.Y.
 Museum purchase with funds from the J. Stanley Coyne Foundation, 1980.

84. *Lake Louise, Canadian Rockies*
 Oil on Belgian linen 5 x 10
 Signed l.r.
 Collection: Sylvain and Anne Van Gobes

85. *Landscape*
 Oil on canvas 11 x 13
 Signed verso
 Collection: Onondaga Historical Association, Syracuse, N.Y.

86. *Landscape*
 Oil on canvas 12 x 18
 Signed l.r.
 Collection: Sylvain and Anne Van Gobes

87. *Landscape*
 Oil on wood panel 5 x 8
 Signed l.r.
 Collection: Sylvain and Anne Van Gobes

88. *Landscape*, 1883
 Oil on canvas 26 x 48
 Signed and dated l.l.
 Collection: Alexander Gallery, New York, N.Y.

89. *Landscape*, 1886
 Oil on canvas 8 x 13
 Signed l.r. and dated verso
 Collection: Alexander Gallery, New York, N.Y.

90. *Landscape*
 Oil on academy board 5 x 8
 Signed l.r.
 Collection: Richard J. Fay

91. *Landscape*
 Oil on canvas dimensions unknown
 Signed l.r.
 Private Collection

*92. *Landscape*
Oil on canvas 15 x 20
Signed l.r.
Collection: Mr. and Mrs. John Bishop

*93. *Landscape of Country Estate and Vineyards*
Oil on canvas 10 x 18
Not signed
Private Collection

94. *Landscape: View of Seneca Lake from Geneva, N.Y., 1886*
Oil on canvas 12 x 19
Signed and dated l.r.
Collection: Gerold Wunderlich & Co., New York, N.Y.

95. *Landscape with Cows and Sheep*
Oil on canvas 30 x 54
Signed l.r.
Collection: Mark LaSalle Fine Art, Albany, N.Y.

96. *Landscape with Cows, Dog and Sheep*
Oil on canvas 8 x 15
Signed l.r.
Collection: George Rosenthal

97. *Landscape with Farm*
Oil on canvas 9 x 12
Signed l.r.
Private Collection
Courtesy Eric Silver

98. *Launch on a Lake*
Oil on canvas 15 x 26
Signed l.r.
Collection: William B. Ruger

*99. *Niagara River at La Salle, 1881*
Oil on canvas 12 x 18
Signed and dated l.r.
Collection: Mr. and Mrs. Robert G. Donnelley

100. *Onondaga Creek, above Syracuse, N.Y.*
Oil on canvas 12 x 18
Signed l.r. and titled verso
Collection: Rodger Sweetland

*101. *Pine Trees along a Deserted Road*
Oil on canvas 12 x 16
Signed l.l.
Collection: Mr. and Mrs. Kenneth Bower

*102. *Pleasure Boats on a Lake*
Oil on canvas 26 x 48
Not signed
Collection: Masco Collection

103. *River Landscape*
Oil on canvas 9 x 12
Not signed
Collection: Kenton B. Jones

104. *Seascape, 1884*
Oil on canvas 15 x 26
Signed and dated l.r.
Collection: Kenneth and Ruth Rhodes

*105. *Seascape*
Oil on canvas 24 x 42
Signed l.r.
Collection: Kenneth and Ruth Rhodes

*106. *South of Sherburne on the Chenango, 1875*
Oil on board 43 x 72
Signed and dated l.r.
Collection: Roberson Museum and Science Center, Binghamton, N.Y.

*107. *A Summer Romance*
Oil on canvas 12 x 18
Signed l.l.
Collection: Mrs. James F. Chace

108. *1000 Islands, Alexandria Bay, St. Lawrence River, N.Y.*
Oil on board 10 x 13
Signed l.r. and titled verso
Collection: Dennis J. Carey

109. *W. Seneca, near Buffalo, N.Y.*
Oil on canvas 9 x 12
Signed l.r. and titled verso
Collection: Kenton B. Jones

110. *Buffalo, N.Y.*
Oil on canvas 15 x 26

111. *Cliff by a Lake*
Oil on board 9 x 5
Initialed l.r. and signed verso

112. *Early Autumn*
Oil on canvas 16 x 20
Signed l.r.

113. *Entering the Thousand Islands*
Oil on canvas 26 x 48

114. *Harbor Islands*
Oil on canvas 10 x 18
Signed l.r.

115. *House on the Hill*
Oil on canvas 12 x 18
Not signed

116. *Hudson River Landscape*
Oil on canvas 7 x 12
Signed l.r.

117. *The Indian Reservation, looking Westward from the Spafford Hills*
Oil on canvas

118. *Landscape* (sketch)
Oil on canvas

119. *Landscape* (sketch)
Oil on canvas

120. *Landscape with Cows*
Oil on canvas

121. *The Mariposa Trail,* ca. 1873
Oil on canvas

122. *Mohawk River Valley Landscape,* 1873
Oil on canvas 43 x 73
Signed and dated l.r.

123. *Mountain Landscape with a Church Steeple in the Distance*
Oil on board 10 x 5
Initialed and inscribed verso

124. *New York State View,* ca. 1885
Oil on canvas 11 x 19

125. *Niagara Falls,* 1884
Oil on canvas 18 x 35

126. *Niagara Falls,* 1884
Oil on canvas

127. *Niagara Falls*
Oil on canvas 12 x 19
Signed l.l.

128. *The North Dome of the Yosemite,* ca. 1873
Oil on canvas

129. *Off Westpoint*
Oil on canvas

130. *River Landscape*
Oil on canvas 7 x 12

131. *River Landscape with Cows,* 1894
Oil on canvas 23 x 40
Signed and dated l.r.

132. *Seascape*
Oil on canvas 12 x 20
Signed l.l.

133. *Shore of Niagara River—Fort Erie,* 1886
Oil on canvas 11 x 19
Signed and dated l.l.

134. *Snowy Landscape with Fir Tree*
Oil on panel 11 x 6
Signed l.l.

135. *St. Lawrence and the Thousand Islands*
Oil on canvas

136. *Sunday in the Afternoon*
Oil on canvas 42 x 72

137. *Thousand Island House, Alexandria Bay*
Oil on canvas 66 x 36

138. *The Valley of the Onondaga*
Oil on canvas

139. *Waterfall*
Oil on panel 11 x 6
Signed l.r.

*140. *An Abundance of Apples*
Oil on canvas 10 x 18
Signed l.r.
Collection: Montclair Art Museum,
Montclair, N.J.
Mary Ellen Wilde and James Turner,
by exchange.

141. *Afternoon Tea with Strawberries*
Oil on canvas 16 x 20
Not signed
Private Collection

142. *Apple Harvest*
Oil on canvas 15 x 19
Initialed l.r. and signed verso
Collection: Brandywine River Museum,
Chadds Ford, Pa.

143. *Apples*, 1889
Oil on canvas 12 x 15
Signed and dated l.r.
Collection: New York State Museum,
Albany, N.Y.

144. *Apples*
Oil on canvas 12 x 18
Signed l.r.
Private Collection

145. *Apples*
Oil on canvas 12 x 16
Signed l.r.
Private Collection

146. *Apples*
Oil on canvas 14 x 20
Not signed
Private Collection

147. *Apples*
Oil on canvas 16 x 13
Signed l.r.
Collection: L. Knife & Son Collection,
Kingston, Mass.

148. *Apples and Tree Trunk*, 1891
Oil on canvas 12 x 10
Signed and dated l.l.
Collection: Alana and Michael Jackson

*149. *Apples in a Basket*, 1891
Oil on canvas 20 x 16
Signed and dated on barrel stay
Collection: Walter and Lucille Rubin

150. *Apples in a Basket*
Oil on canvas 12 x 19
Signed on basket handle
Collection: Richard York Gallery,
New York, N.Y.

151. *Apples in a Basket*
Oil on canvas 12 x 18
Signed l.r. and verso
Collection: Richard J. Fay

152. *Apples in a Brown Hat*
Oil on canvas 12 x 18
Signed l.r. and verso
Private Collection

153. *Apples in a Hat*
Oil on canvas 12 x 18
Signed l.l.
Collection: Berry-Hill Galleries,
New York, N.Y.

154. *Apples in a Straw Hat*
Oil on canvas 20 x 14
Signed l.r.
Private Collection

155. *Apples in a Tin Basin*
Oil on canvas 12 x 16
Signed l.r.
Collection: Walter and Lucille Rubin

*156. *Apples in a Tin Pail*, 1892
Oil on canvas 16 x 13
Signed and dated l.r.
Collection: Museum of Fine Arts,
Boston, Mass.
The Hayden Fund.

157. *Apples Spilling from a Basket*
Oil on canvas 12 x 20
Signed l.r.
Collection: Gerold Wunderlich & Co.,
New York, N.Y.

158. *Apples under a Tree*
Oil on canvas 12 x 23
Signed l.r.
Collection: William B. Ruger

*159. *Bag of Apples*, 1894
Oil on canvas 11 x 18
Signed and dated l.r.
Collection: Louisiana Arts and Science
Center, Baton Rouge, La.

160. *Bananas and Apples*
Oil on canvas 10 x 12
Signed l.r.
Private Collection

161. *Basket of Apples*, 1890
Oil on canvas 12 x 18
Signed and dated l.r.
Collection: Onondaga Historical
Association, Syracuse, N.Y.

162. *Basket of Apples*, 1895
Oil on canvas 22 x 18
Signed and dated on basket stay
Collection: Dayton Art Institute,
Dayton, Ohio
Museum purchase with funds provided
by Mrs. Norman Thal in memory of
Norman Thal.

163. *Basket of Apples beneath a Tree*, 1891
Oil on canvas 16 x 12
Signed and dated on basket stay and
verso
Private Collection

*164. *Basket of Apples beneath a Tree*
Oil on canvas 10 x 18
Signed l.r.
Collection: Gilbert Butler

165. *Basket of Peaches*
Oil on canvas 12 x 10
Signed l.r.
Collection: Hirschl & Adler Galleries,
New York, N.Y.

166. *Baskets of Strawberries*, 1889
Oil on canvas 9 x 15

Signed and dated l.r.
Private Collection

*167. *Baskets of Strawberries and Gooseberries on a
Ledge*
Oil on canvas 16 x 20
Signed l.r.
Private Collection

*168. *Bed of Strawberries with Monarch Butterfly*
Oil on canvas 12 x 16
Signed l.r.
Collection: Edward and Vivian Merrin

169. *Berries*
Oil on canvas 7 x 13
Signed l.r.
Collection: Sylvain and Anne
Van Gobes

*170. *Bushels of Apples under a Tree*
Oil on canvas 24 x 20
Not signed
Collection: Eleanor M. Foster

171. *Bushels of Apples under a Tree*
Oil on canvas 20 x 16
Signed on basket stay
Private Collection

172. *Bushels of Apples under a Tree*
Oil on canvas 24 x 20
Signed l.r. and verso
Private Collection

173. *Cantaloupe*
Oil on canvas 9 x 12
Signed l.r.
Collection: Adirondack Museum,
Blue Mountain Lake, N.Y.
Gift of Margaret Prentice Lawrence,
artist's great grandniece.

174. *Cherries*
Oil on canvas 10 x 8
Signed l.r.
Private Collection

*175. *Cherries and Raspberries in a Basket*, 1891
Oil on canvas 12 x 19
Signed and dated l.r.

Collection: Hood Museum of Art,
Dartmouth College, Hanover, N.H..
Purchase made possible through the
Miriam and Sidney Stoneman Fund
and through gifts by John W.
Thompson, Dorothea M. Litzinger and
Russell Cowles, by exchange.

*176. *Cherries in a Basket*, ca. 1895
Oil on canvas 12 x 18
Signed l.r.
Collection: Yale University Art Gallery,
New Haven, Conn.
John Hill Morgan, B.A. 1893, Fund.

*177. *Cherries on a Bough*, ca. 1895
Oil on canvas 9 x 15
Signed l.r.
Collection: Joan B. Mirviss and Robert
J. Levine

178. *Crabapples Hanging from a Tree*
Oil on canvas 12 x 10
Signed l.r.
Collection: Albany Institute of History
and Art, Albany, N.Y.

*179. *Fish, Lobster and Radishes*
Oil on canvas 12 x 18
Not signed
Private Collection

*180. *Flowering Plant against a Fence*
Oil on canvas 26 x 18
Signed l.l.
Collection: Berry-Hill Galleries,
New York, N.Y.

*181. *Forest Floor*
Oil on canvas 5 x 11
Signed l.r.
Collection: Remak Ramsay

182. *Fruit on a Tabletop*
Oil on canvas 10 x 16
Signed l.r.
Collection: Berry-Hill Galleries,
New York, N.Y.

*183. *Gooseberries, Plums, Pineapple and
Cantaloupe*, 1899
Oil on canvas 12 x 18
Signed and dated l.r.
Private Collection

184. *Grapes Hanging from a Board*
Oil on canvas 15 x 12
Not signed
Collection: Rahr-West Art Museum,
Manitowoc, Wis.

185. *Green and Red Peppers*
Oil on canvas 10 x 12
Not signed
Collection: Bogart Gallery,
New York, N.Y.

186. *Green Apples in a Landscape*, 1889
Oil on canvas 9 x 15
Signed and dated l.l.
Collection: William B. Ruger

187. *Landscape with Apple Tree*
Oil on canvas 20 x 16
Signed l.r.
Private Collection

188. *The Lobster*
Oil on canvas 12 x 16
Not signed
Private Collection

189. *Lobster on a Tabletop*
Oil on canvas 12 x 18
Signed l.r.
Collection: Joseph T. Butler

190. *Lobster on Marble Tabletop*
Oil on canvas 12 x 18
Signed l.r.
Collection: Rahr-West Art Museum,
Manitowoc, Wis.

191. *Melons*
Oil on canvas 12 x 18
Not signed
Private Collection

*192. *Melons, Peaches and Pineapple*
Oil on canvas 12 x 19
Signed l.r.
Collection: Walter and Ann Knestrick

193. *Overturned Basket of Apples Under a Tree*
Oil on canvas 12 x 18
Signed on basket stay
Private Collection

194. *Overturned Basket of Peaches*, 1889
Oil on canvas 16 x 13
Signed and dated l.r. and verso
Collection: Gerold Wunderlich & Co.,
New York, N.Y.

195. *Overturned Basket of Peaches and Landscape in Background*
Oil on canvas 20 x 16
Signed l.r.
Collection: Mrs. John A. Harney

196. *Pansies and Nasturtiums*
Oil on canvas 12 x 6
Initialed l.r.
Private Collection

197. *Peaches*, 1884
Oil on canvas 12 x 19
Signed l.r. and verso
Collection: Alana and Michael Jackson

198. *Peaches*
Oil on canvas 20 x 24
Not signed
Private Collection

199. *Peaches and Baskets*
Oil on canvas 11 x 16
Signed l.r.
Private Collection

200. *Peaches in a Basket*
Oil on canvas 12 x 18
Signed on basket
Private Collection

*201. *Peaches in a Basket*
Oil on canvas 10 x 14
Signed l.r.
Collection: Walter and Lucille Rubin

*202. *Peaches in a Landscape*
Oil on canvas 16 x 20
Signed l.r.
Private Collection

203. *Peaches in a Silver Bowl*
Oil on canvas 12 x 18
Signed l.r.
Collection: Philbrook Museum of Art,
Tulsa, Okla.
Gift of Friends of Philbrook in honor
of Reading and Bates Corporation and
Maxine M. Holleman, with special appreciation to Mr. and Mrs. Charles E.
Thornton.

204. *Peaches Spilling from a Basket*
Oil on canvas 12 x 18
Signed on basket
Private Collection

205. *Pineapple, Berry Box and Gooseberries*
Oil on canvas 9 x 15
Signed l.r.
Collection: Rahr-West Art Museum,
Manitowoc, Wis.

206. *Plums*
Oil on canvas 17 x 22
Signed l.r.
Private Collection

*207. *Raspberry Bush*
Oil on canvas 7 x 15
Signed l.r.
Collection: Rahr-West Art Museum,
Manitowoc, Wis.

208. *Raspberries with Pan*
Oil on canvas 12 x 9
Signed l.r.
Private Collection

209. *Ready for Picking*
Oil on canvas 12 x 10
Not signed
Private Collection

210. *Red and Green Plums*
Oil on canvas 14 x 20

Signed l.r.
Collection: Mellon Bank Corporation

211. *Red Currants*
Oil on canvas 6 x 9
Signed l.r.
Private Collection

212. *Red Plums, Purple Plums*, ca. 1890
Oil on canvas 17 x 20
Signed l.r.
Collection: Theodore Stebbins, Jr.

213. *Red Raspberries Spilling from a Basket*
Oil on canvas 8 x 10
Signed l.r.
Collection: Morris Collection

214. *Sea Shells*
Oil on canvas 12 x 16
Signed l.r. and verso
Collection: Richard York Gallery,
New York, N.Y.

215. *Spilling Crabapples*
Oil on canvas 10 x 16
Signed l.r.
Private Collection

216. *Still Life with Basket of Strawberries*
Oil on canvas 12 x 10
Signed l.r.
Private Collection

217. *Still Life with Bass Ale and Oysters*
Oil on canvas 16 x 20
Signed l.r.
Collection: Mr. and Mrs. John A.
Simkiss, Jr.

*218. *Still Life with Berries*
Oil on canvas 9 x 15
Signed l.r.
Private Collection

*219. *Still Life with Bowl of Fruit*, 1890
Oil on canvas 16 x 13
Signed and dated l.r.
Collection: Berry-Hill Galleries,
New York, N.Y.

220. *Still Life with Corn*
Oil on canvas 10 x 18
Not signed
Private Collection

221. *Still Life with Fruit and Fly*
Oil on canvas 9 x 12
Signed l.r.
Collection: William B. Ruger

222. *Still Life with Fruit on a Tabletop*
Oil on canvas 17 x 14
Signed l.r.
Collection: Mary and Ed Ryan

*223. *Still Life with Oysters*, ca. 1890
Oil on canvas 16 x 22
Signed l.r.
Collection: The Regis Collection

224. *Still Life with Peaches*, 1889
Oil on canvas 11 x 18
Signed and dated l.r.
Collection: Garzoli Gallery,
San Rafael, Calif.

*225. *Still Life with Pears*
Oil on canvas 6 x 9
Signed l.r.
Collection: Sylvain and Anne
Van Gobes

*226. *Still Life with Pears and Grapes*
Oil on canvas 10 x 16
Signed l.r.
Private Collection

227. *Still Life with Pears, Peaches and Grapes*
Oil on canvas 12 x 18
Signed l.r.
Collection: Sylvain and Anne
Van Gobes

228. *Still Life with Plums*
Oil on canvas 9 x 12
Signed l.r.
Collection: Jerald Dillon Fessenden

*229. *Still Life with Plums*
Oil on canvas 12 x 18
Signed l.r.
Collection: Detroit Institute of Arts,
Detroit, Mich.
Founders Society Purchase,
Merrill Fund.

*230. *Still Life with Strawberries*, ca. 1890
Oil on canvas 16 x 20
Signed l.r.
Collection: Carnegie Museum of Art,
Pittsburgh, Pa.
Mary Oliver Robinson Fund, Bequest
to the Women's Committee, Museum
of Art; and Women's Committee
Acquisition Fund, 1981.

231. *Still Life with Strawberries*
Oil on canvas 12 x 18
Signed l.r. and verso
Collection: Berry-Hill Galleries,
New York, N.Y.

232. *Still Life with Vegetables*
Oil on canvas 7 x 12
Signed l.r.
Collection: Adirondack Museum, Blue
Mountain Lake, N.Y.
Gift of Elizabeth Prentice Cassidy,
artist's grandniece.

233. *Strawberries*, 1892
Oil on canvas 12 x 19
Signed and dated l.r.
Collection: Dr. Diane Tanenbaum Lux

234. *Strawberries*, 1898
Oil on canvas 10 x 14
Signed l.r.
Collection: Thomas E. Grimshaw

235. *Strawberries*
Oil on canvas 6 x 10
Signed l.r.
Private Collection

236. *Strawberries and Cream*
Oil on canvas 12 x 18
Signed l.r.
Private Collection

*237. *Strawberries Spilling from a Basket and
Growing on a Bush*
Oil on canvas 12 x 10
Signed l.r.
Collection: Mr. and Mrs. Howard
J. Godel

*238. *Tea, Cake and Strawberries*
Oil on canvas 16 x 20
Signed l.r.
Private Collection

239. *Wildflowers*
Oil on canvas 12 x 6
Signed l.r.
Collection: David McCabe

240. *Willowware and Strawberries*
Oil on canvas 10 x 14
Not signed
Private Collection

LOCATION UNKOWN

241. *Apples*, 1884
Oil on canvas

242. *Apples*
Oil on canvas 16 x 13

243. *Apples in a Hat*, 1891
Oil on canvas 16 x 13
Signed and dated c.r. and verso

244. *Bag of Raspberries*
Oil on canvas 7 x 16
Signed l.r.

245. *Bag of Strawberries*
Oil on canvas 7 x 16
Signed l.r.

246. *Basket of Apples*
Oil on canvas 12 x 18
Signed l.r. and verso

247. *Basket of Apples*
Oil on canvas
Signed l.r.

248. *Basket of Apples Under a Tree*
Oil on canvas 12 x 18
Signed on basket and verso

249. *A Basket of Cherries*, 1897
Oil on canvas 16 x 22
Initialed and dated

250. *A Basket of Cherries*
Oil on canvas 13 x 19
Signed verso

251. *Basket of Peaches*
Oil on canvas 10 x 12
Signed l.r.

252. *Basket of Peaches*
Oil on canvas 14 x 12
Signed l.r.

253. *Bushel Basket of Peaches on Tabletop*
Oil on canvas

254. *Bushels of Peaches Under a Tree*
Oil on canvas 24 x 20
Signed l.r.

255. *Cherries*
Oil on canvas board 7 x 11
Signed l.r.

256. *Cherries in a Tin Pail*, 1890
Oil on canvas 10 x 15
Signed and dated l.r.

257. *Cherries on a Leaf*
Oil on canvas 12 x 10
Signed l.l.

258. *Footed Bowl and Baskets of Strawberries*
Oil on canvas 9 x 14
Signed l.r.

259. *Late September*
Oil on canvas 16 x 20
Signed l.r.

260. *Peaches*, 1886
Oil on canvas 11 x 18
Signed and dated on ladder

261. *Peaches*
Oil on canvas 12 x 16
Signed l.r.

262. *Peaches in a Basket*
Oil on canvas 14 x 18
Signed l.c.

263. *Peaches in a Bushel Basket*
Oil on canvas 16 x 20
Signed l.r.

264. *Peaches on a Tabletop*
Oil on canvas 8 x 10
Signed l.r.

265. *Plums*
Oil on canvas 9 x 15
Signed l.r.

266. *Raspberries on a Leaf*
Oil on canvas
Signed l.r.

267. *Reflecting Apples and Melons*
Oil on canvas 12 x 18
Signed on basket stay

268. *Spilled Apples*
Oil on panel 13 x 18
Signed l.r.

269. *Still Life with Apples in a Basket*
Oil on canvas 12 x 18
Signed l.r.

270. *Still Life with Basket of Strawberries*
Oil on canvas 12 x 10
Signed l.r.

271. *Still Life with Currants on a Leaf*
Oil on canvas 10 x 12
Signed l.r.

272. *Still Life with Peaches*
Oil on canvas 12 x 18
Signed on basket

273. *Still Life with Plums*
Oil on canvas 12 x 18
Signed l.r. and verso

274. *Still Life with Raspberries*
Oil on canvas 14 x 18
Signed l.l.

275. *Strawberries and Baskets*, 1892
Oil on canvas 12 x 19
Signed and dated l.r.

276. *Strawberries and Iced Cake*
Oil on canvas 16 x 22
Signed l.l.

277. *Tomatoes and Cucumbers*
Oil on canvas 10 x 12

PORTRAITS

*278. *Afternoon Idyll*, 1920
Oil on canvas 15 x 20
Signed and dated l.r.

Collection: Anderson & Co. Fine Arts,
Grosse Point Farms, Mich.

LOCATION UNKNOWN

279. *Leigh Prentice*
Oil on canvas 16 x 12
Signed l.r.

280. *Self-Portrait*
Oil on canvas

ANIMALS

*281. *Barnyard Scene*
Oil on canvas 12 x 18
Signed l.r.
Private Collection

282. *Cats*
Oil on canvas 12 x 18
Signed l.r.
Collection: William B. Ruger

283. *Kitty-Cat*
Oil on canvas 9 x 13
Signed l.r.
Collection: Michele Van Gobes

*284. *Pig-Pen*
Oil on canvas 12 x 18

Signed l.r.
Collection: Susan Ellis Stebbins

*285. *A Portrait*
Oil on canvas 24 x 20
Signed l.r.
Collection: Yale University Art Gallery,
New Haven, Conn.
Joseph D. Schwerin, B.A. 1960, Fund.

*286. *Tibby* [Imogene's cat]
Oil on canvas 13 x 19
Signed l.r.
Collection: Sylvain and Anne
Van Gobes

NOTE: *The following paintings came to light as this book was going to press and are included here as an addendum to the above checklist.*

Adirondack Landscape
Oil on canvas 24 x 18
Signed l.r.
Private Collection

Adirondack Landscape
Oil on canvas 6 x 12
Signed l.r.
Private Collection

Adirondack Lake
Oil on canvas 8 x 6
Signed l.r.
Private Collection

Beardsley Park Falls, Beardsley Park, Connecticut
Oil on canvas 5 x 9
Signed l.r.
Private Collection

Blue Mountain Lake
Oil on canvas 8 x 6
Signed l.r.
Private Collection

Central New York Landscape
Oil on canvas 12 x 24
Signed l.r.
Private Collection

Chopping Wood
Oil on canvas 15 x 27
Signed l.r.

Country Lane
Oil on canvas 15 x 26
Signed l.r.

A Deer at Lakeside, Summer Afternoon, 1878
Oil on canvas 20 x 35
Signed and dated l.r.

Panoramic View of a Lake in Autumn
Oil on canvas 30 x 44
Signed l.r.

Park in Philadelphia
Oil on canvas 5 x 9
Signed l.r.
Private Collection

Potato Field, Long Island
Oil on canvas 12 x 24
Signed l.r.
Private Collection

Rhoda S. Robbins Prentice (the artist's mother)
Oil on canvas 10 x 8
Signed l.r.
Private Collection

River Landscape with Cows, 1877
Oil on canvas 36 x 67
Signed and dated l.r.
Collection: Floyd Batchelor and Barbara Wilcox

Samuel Wells Prentice (the artist's father)
Oil on canvas 10 x 8
Signed l.r.
Private Collection

Still Life with Apples
Oil on canvas 10 x 12
Signed l.r.
Private Collection

Still Life with Baskets of Plums
Oil on canvas 12 x 18
Signed l.r.
Private Collection

Still Life with Red Flower
Oil on canvas 24 x 12
Signed l.r.
Private Collection

Index

BARBARA L. JONES grew up in Allegany County in western New York and received a B.A. in Art Education from the University of South Carolina and an M.A. in Art History from Syracuse University. She has taught Art History at Syracuse University, Colgate University, and Hobart and William Smith Colleges. Ms. Jones has authored one exhibition catalogue and contributed to several others on twentieth century American and European artists and printmakers. She is currently living in New York City working for Pei Cobb Freed & Partners Architects and as an independent curator of nineteenth and twentieth century American art.